MAINE

Life in a Day

Introduction by Susan Conley

Down East Books

Down East Books

Published by Down East Books
An imprint of Globe Pequot

Distributed by NATIONAL BOOK NETWORK

Copyright © 2017 by Rowman & Littlefield
Photographs © individual photographers
Cover photograph by Fred Field
Designed by Sally Rinehart

British Library Cataloguing in Publication Information available

Library of Congress Cataloging-in-Publication Data available

ISBN 978-1-60893-649-6 (hardcover)
ISBN 978-1-60893-650-2 (e-book)

♾™ The paper used in this publication meets the minimum requirements of American National Standard for Information Sciences—Permanence of Paper for Printed Library Materials, ANSI/NISO Z39.48-1992.

Printed in the United States of America

INTRODUCTION

W hen I was growing up in Maine in the 1970s, we had sheep who were masters at the art of escape. The animals refused to act sheeply or conform really in any way. At night, Gloria and Herbert and Sally — two stubborn ewes and a ram, slipped the fence in the field behind our old farmhouse and climbed the stairs to our front porch, where they stood by the double-tall windows staring at my brother and sister and me while we watched *Happy Days*. This was Woolwich — a small, mid-coast town where the people didn't conform either.

Ship-builders and farmers and pediatricians and math professors and fourth-generation bridge builders lived here. Up and down our small stretch of the Kennebec River, our neighbors canned tomatoes and fed chickens and made it up as they went. Maine was big and forgiving enough for people to re-invent themselves like this back then. It still is.

Each of the photographers here tells a story, start to finish, of what it really means to live here in Maine. This collection testifies to our wooden town docks and our primeval forests and the bearded fishermen and the tattooed chefs who cook the daily catch. There's something deeply empathetic about the stories inside these pages. Every photograph is a singular moment that pulses and shimmers and speaks to the honesty and beauty of the state.

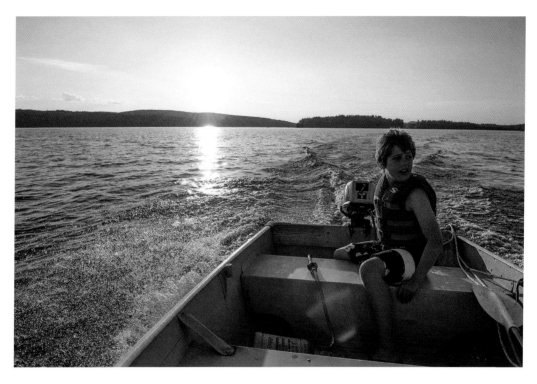

Cruising across Thompson Lake in the putt-putt boat. *(Laura Young)*

For a writer like me, photography has always seemed like the very next best thing to writing. Or maybe *the* best thing. Because the entire story gets told in one press of the camera shutter: a 500-page novel distilled to a single frame. None of these photographs tries to romanticize the state or to render the notion of one, singular Maine. We're an ever-changing place, and geography is one of the only constants in these photos: granite and pine, loping hills and gimlet lakes, the repeating open door of ocean waves.

In this way *Maine: Life in a Day* is pure bounty for the reader, a gorgeous homecoming for anyone touched by Maine—the lucky people who call this state home and the legions who carry Maine in their imaginations but live far away. ∎

— Susan Conley, Portland

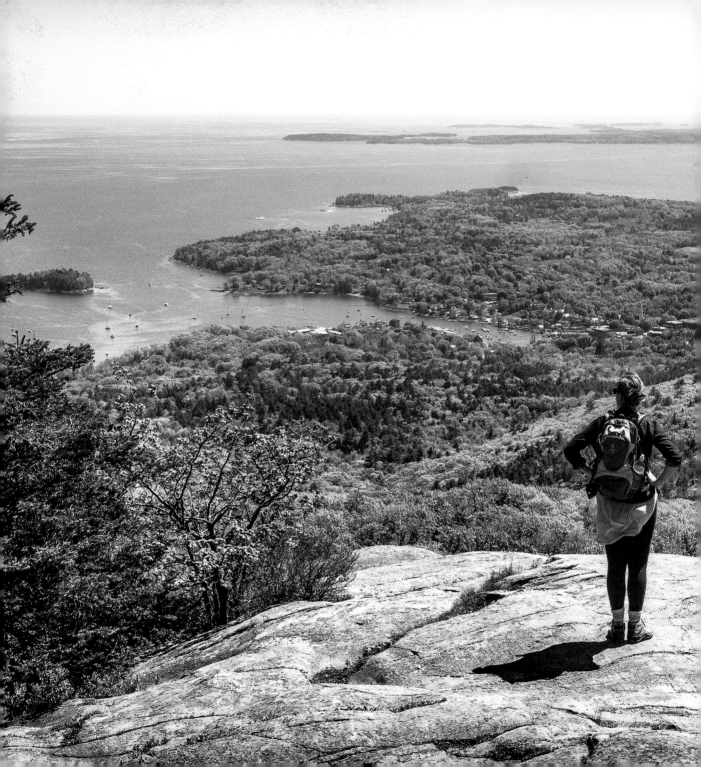

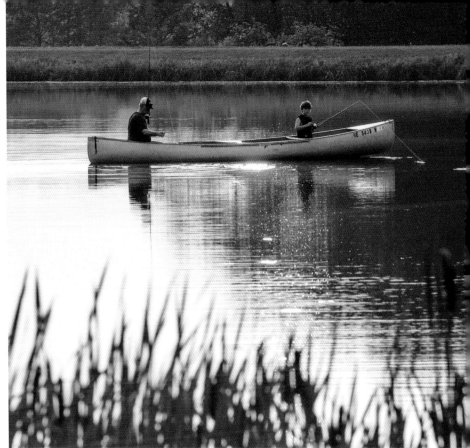

Left: Taking it all in from Mount Battie. *(Benjamin Williamson)*

Right: Early morning fishing, Presque Isle. *(Paul Cyr)*

∾ 5

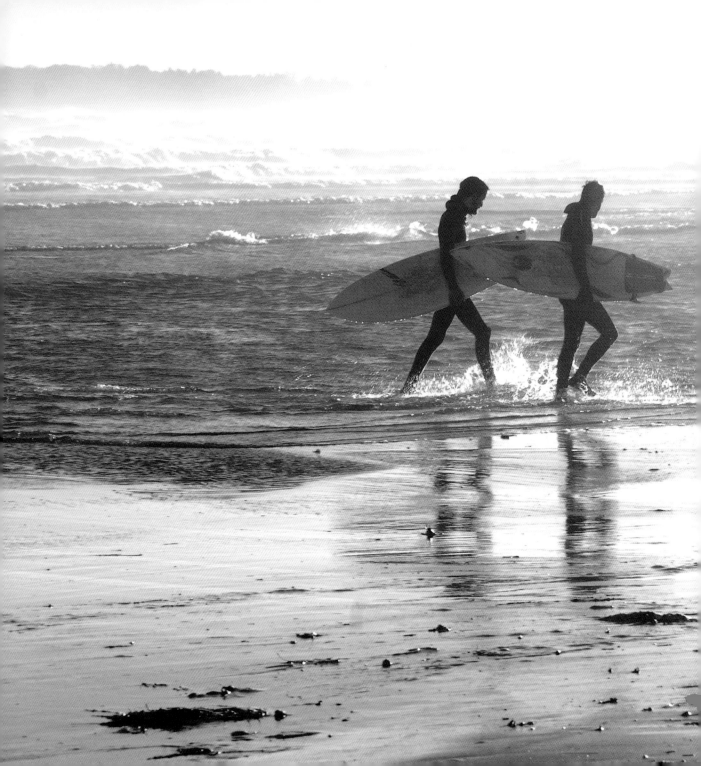

Coming in from a good day of surf-
ing, Higgins Beach, Scarborough.
(Nance Trueworthy)

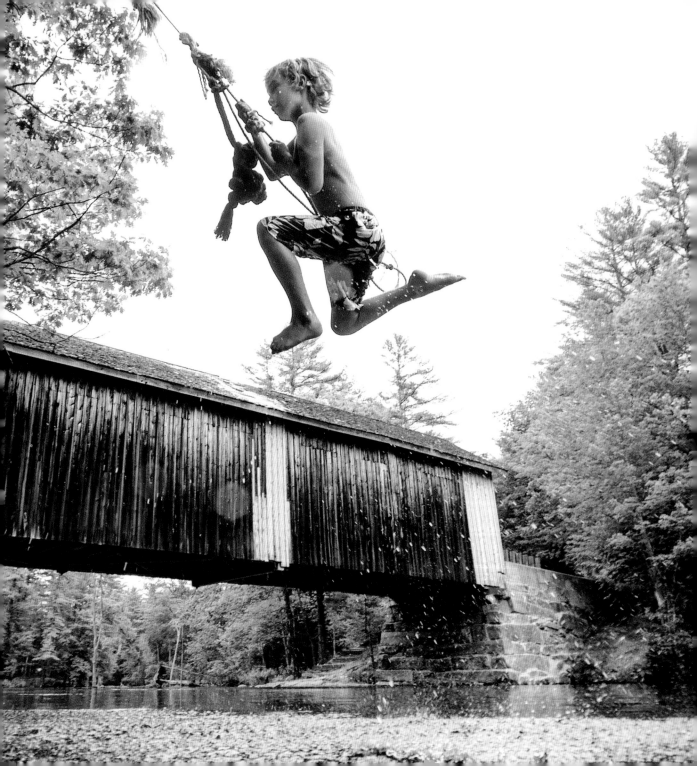

Left: Childhood freedom—when cool water calls in summer. *(Heather Perry)*

Right: A stunningly beautiful summer sunrise greeted James Smith of Boston as he fished just offshore in Kennebunk. He said dawn fishing can be productive. This day it wasn't. *(Fred Field)*

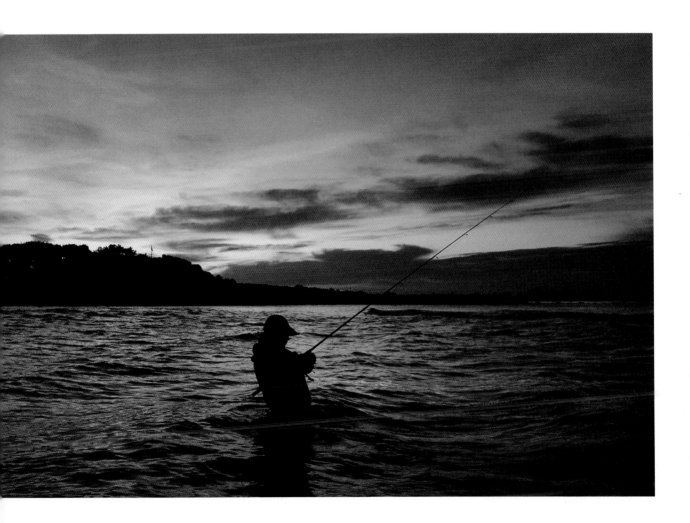

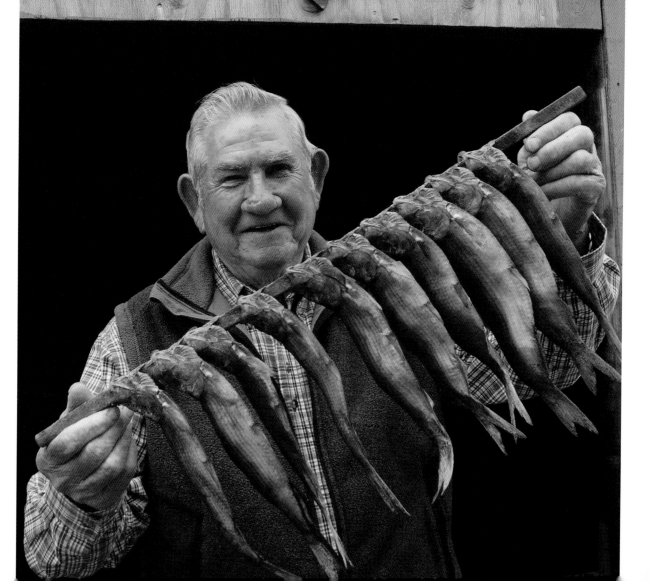

The real Maine is its people; down-to-earth yet creative, full of common sense and wry humor, willing to say yes to a request for help, but nobody's fool. When I stop at a store in Maine I know I will have an interesting exchange with someone before I leave. The natural wonders abound, but the spirit of the Mainer is its treasure.

—Jane Soulos, Sarasota, Florida

Smoked alewives, Damariscotta. *(Nance Trueworthy)*

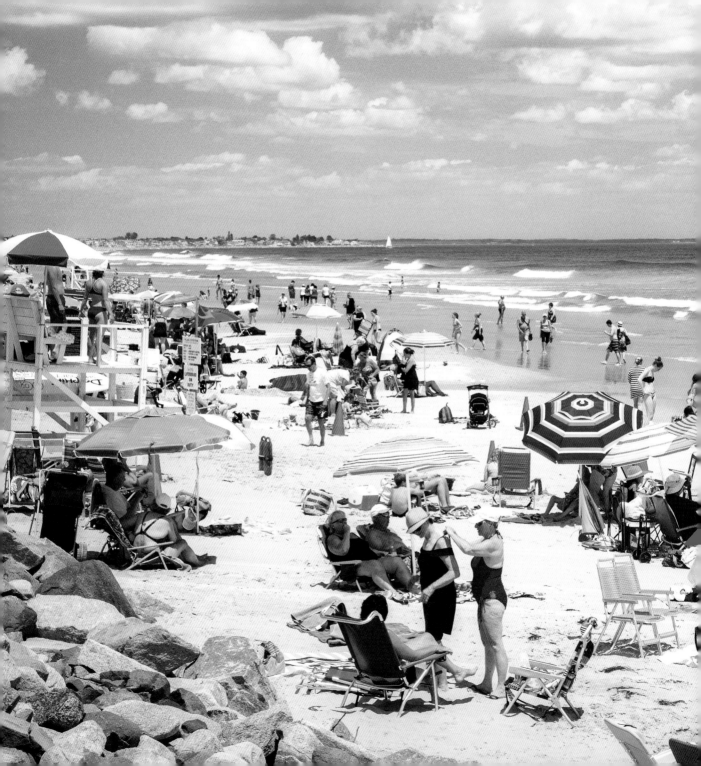

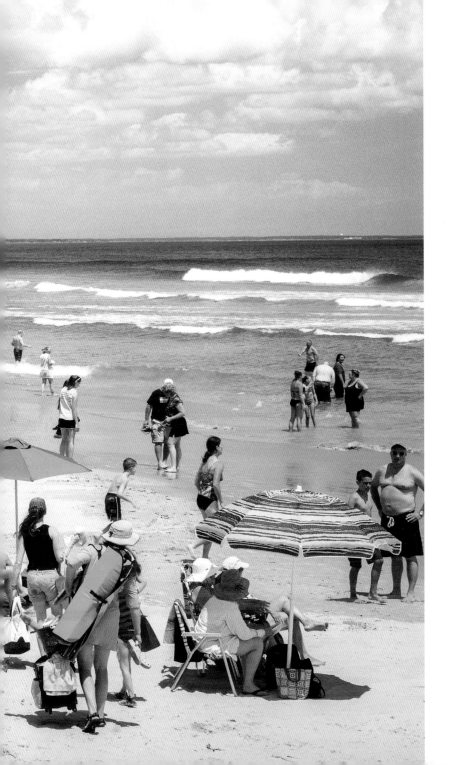

A perfect day at Ogunquit Beach. *(Benjamin Williamson)*

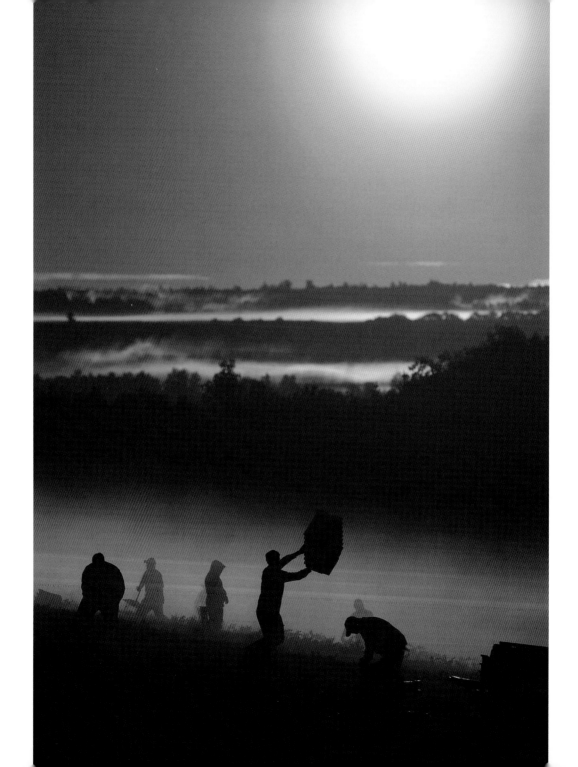

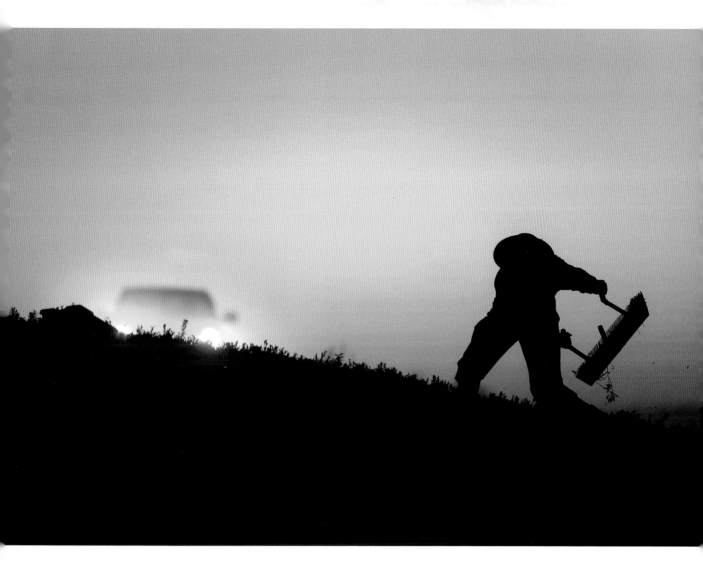

Left: Early morning sun illuminates river valley fog in this view from a Wyman's blueberry field in Deblois, where rakers have already been hard at work for several hours. *(Fred Field)*

Right: A Mexican blueberry raker, already working in the predawn light as fellow rakers arrive at a Wyman's blueberry field in Deblois. *(Fred Field)*

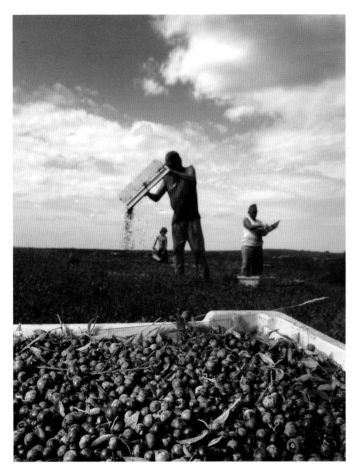

Left: Robert P. Levi of Big Cove, New Brunswick, rakes a blueberry field in Township 19MD. He and many fellow Micmac Indians from New Brunswick and Nova Scotia come to Washington County each August to rake blueberries as their ancestors did. *(Fred Field)*

Right: Fog and early morning sun make for an unusual scene as Wyman's supervisors check a blueberry field in Deblois. *(Fred Field)*

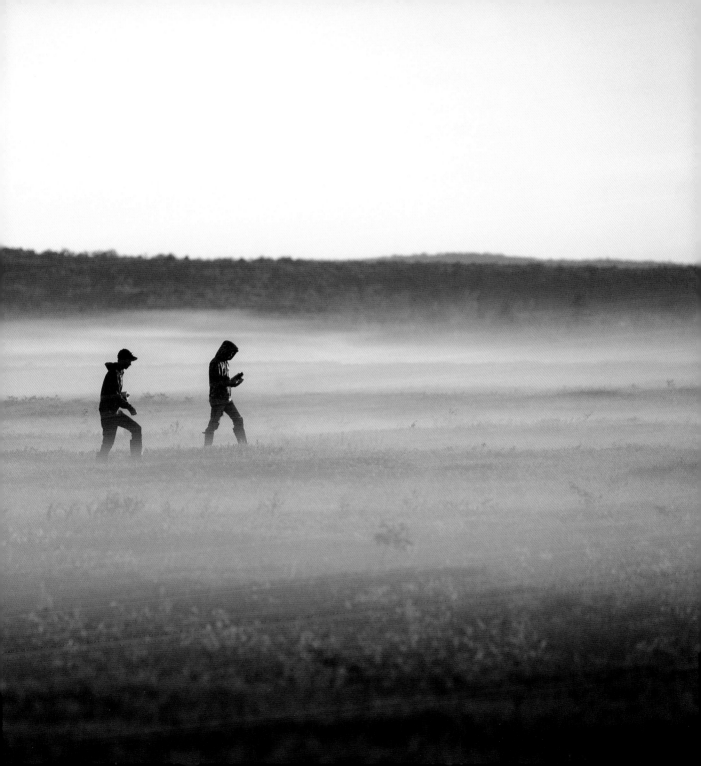

The real Maine is something like this: You have several seasonal jobs year-round. You are always planning for the winter. Do you have enough wood and oil? Do you need new shovels, boots, gloves? You watch the seasonal sales at local stores. You put up food from your garden if you have one. Have you got your hunting permits in order? You are a thrift shop queen for your kids' clothing. You are friends with the folks at your local garage. You are not afraid to ask for a payment plan for anything.

—Emma Finn, Hillsboro, Oregon

Hussey's General Store in Windsor is a Maine institution, where you can literally get a wedding dress and a shotgun— and just about anything else. As their motto says, "If we ain't got it, you don't need it." *(Benjamin Magro)*

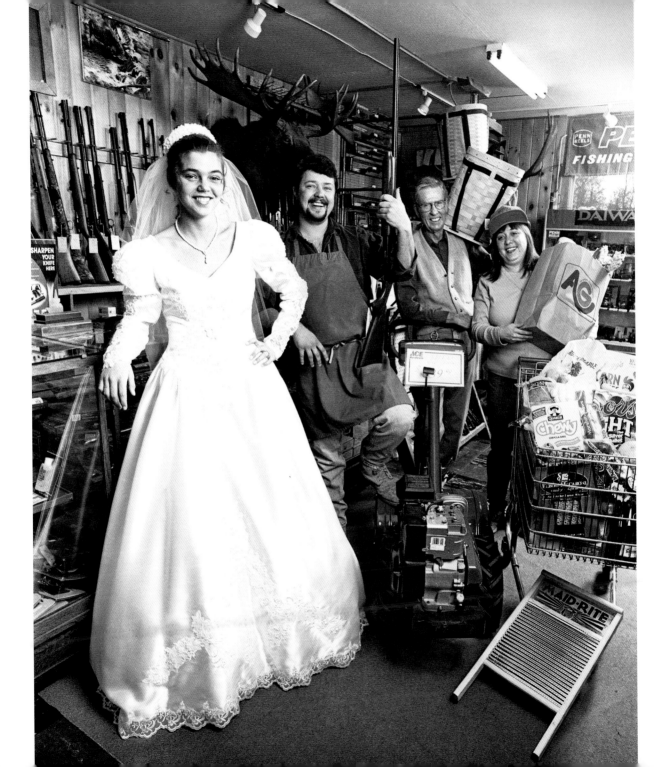

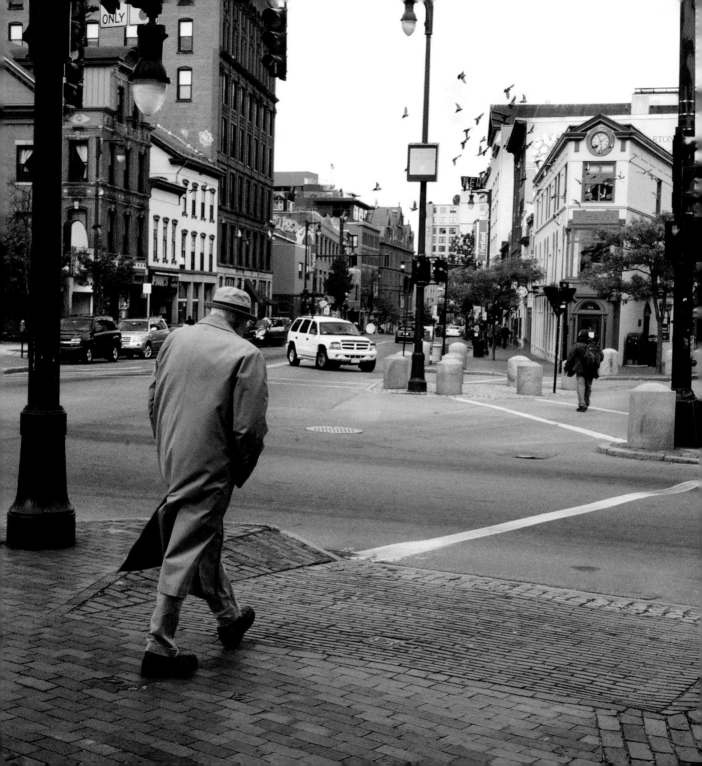

Left: Windblown, Portland. *(Doug Bruns)*

Right: Airborne, Portland. *(Doug Bruns)*

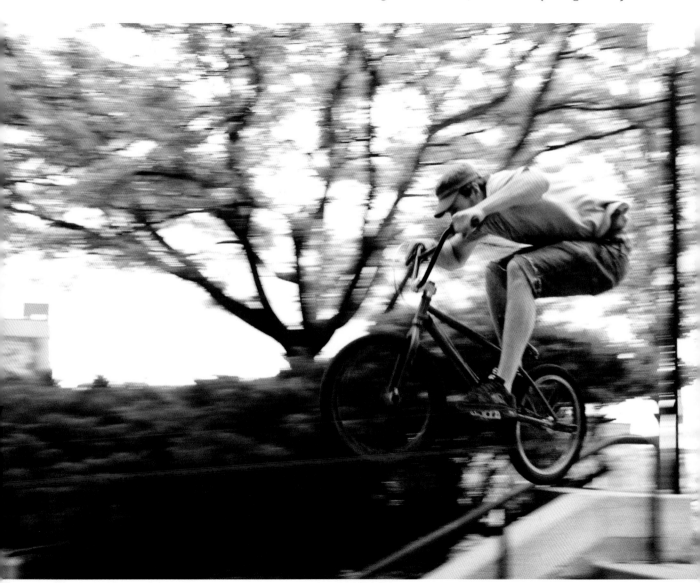

Maine is home to three Amish communities. Everyone joins in to help with a barn raising in Fort Fairfield. *(Paul Cyr)*

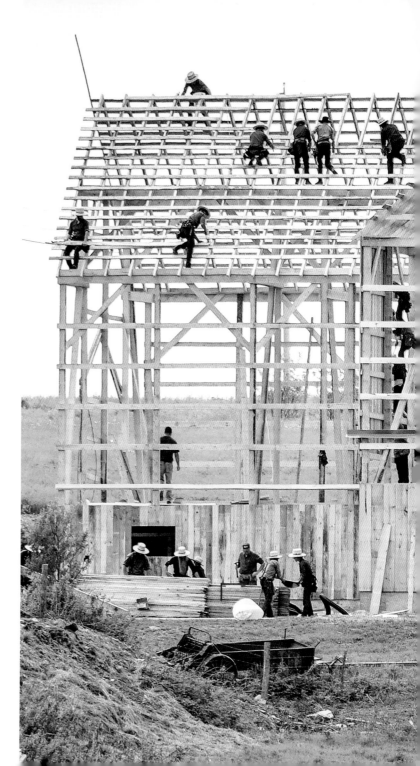

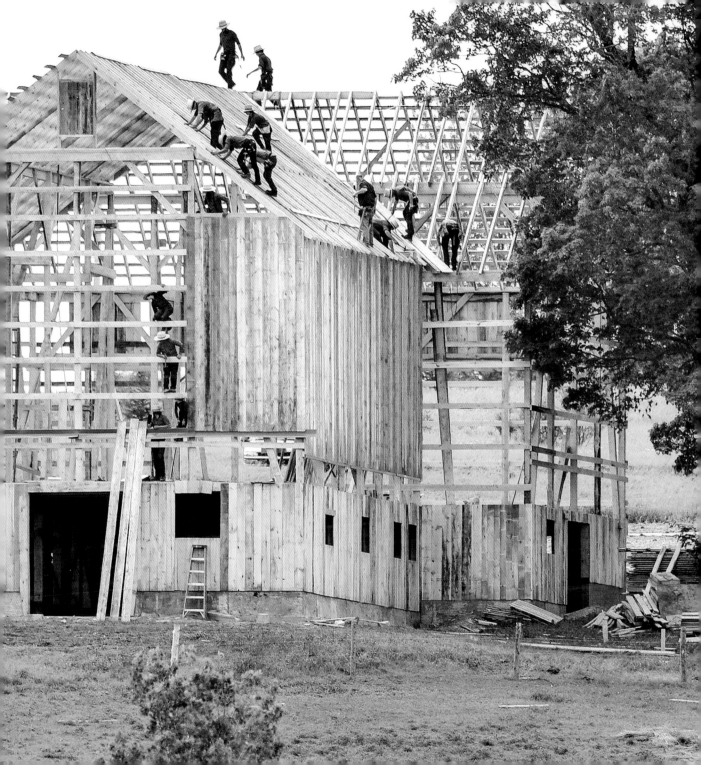

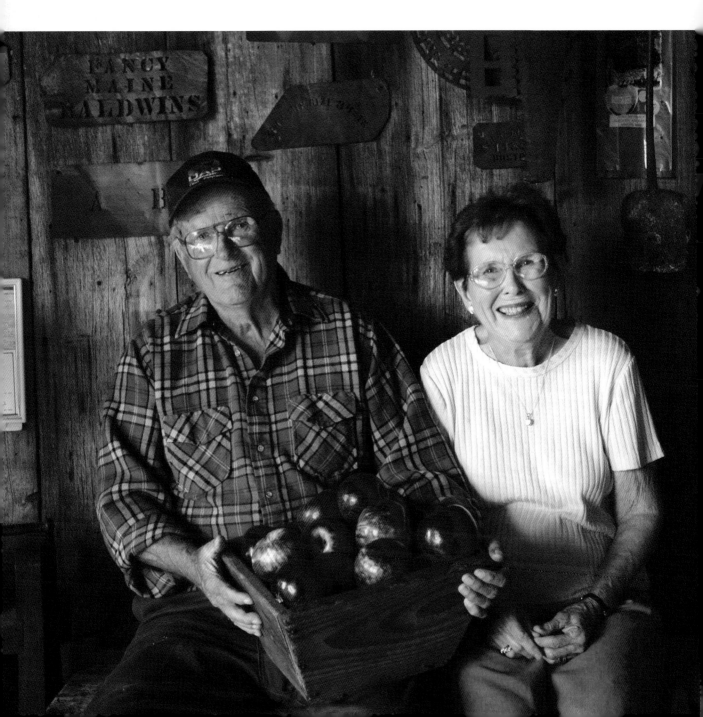

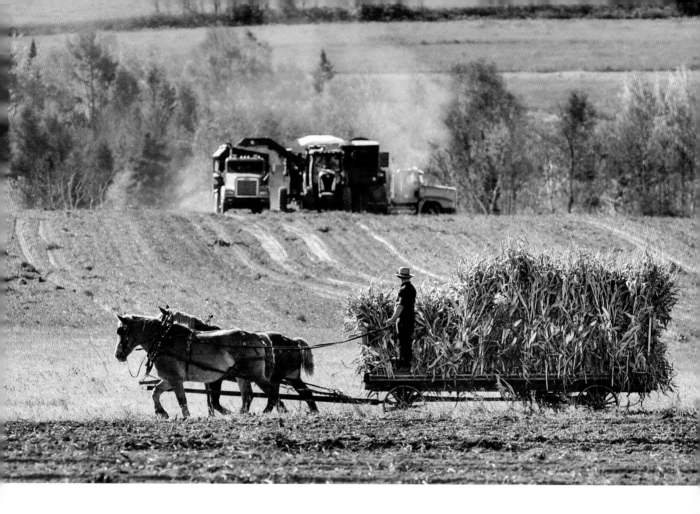

Left: Eighth-generation orchardist Manley Brackett and his wife Virginia hold some prized apples. Brackett's Orchards in Limington is thought to be the oldest family orchard in Maine—the family has been growing apples here since 1783. *(Nance Trueworthy)*

Right: Old tech meets new as an Amish farmer watches his neighbor harvest a crop of potatoes, Fort Fairfield. *(Paul Cyr)*

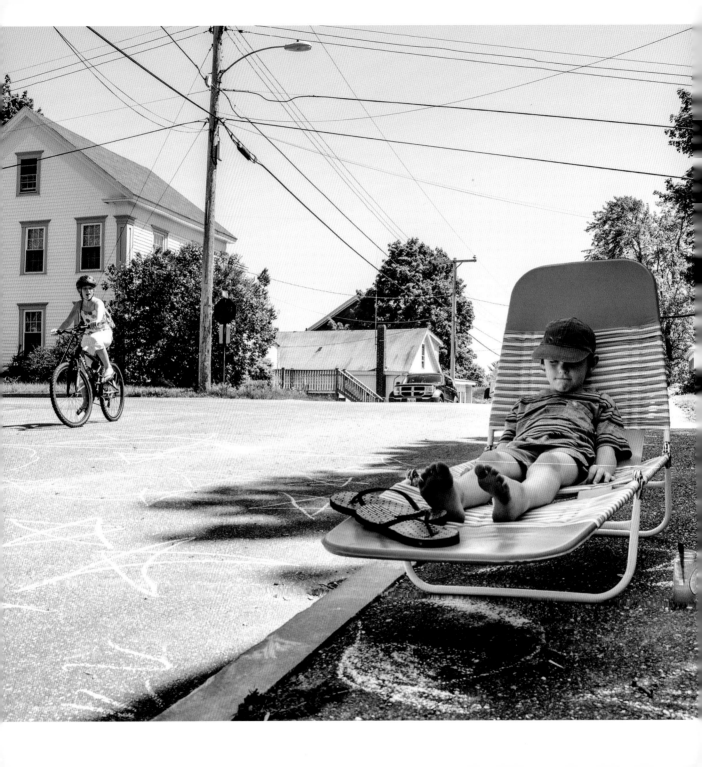

The real Maine is small-town Maine. It's a place where we know everyone, or almost everyone. Idiosyncracies are accepted, if not embraced. Social life is not limited to those in your church, your school, or your occupation, but by mutual interests. Children are safe to run freely. Their life is not overly organized with activities every day. There is actually time for unstructured play. Privacy is respected, but when someone needs help, it's there.

—Alice Moisen, Portland, Maine

Summer vacation in the neighborhood, Bath. *(Heather Perry)*

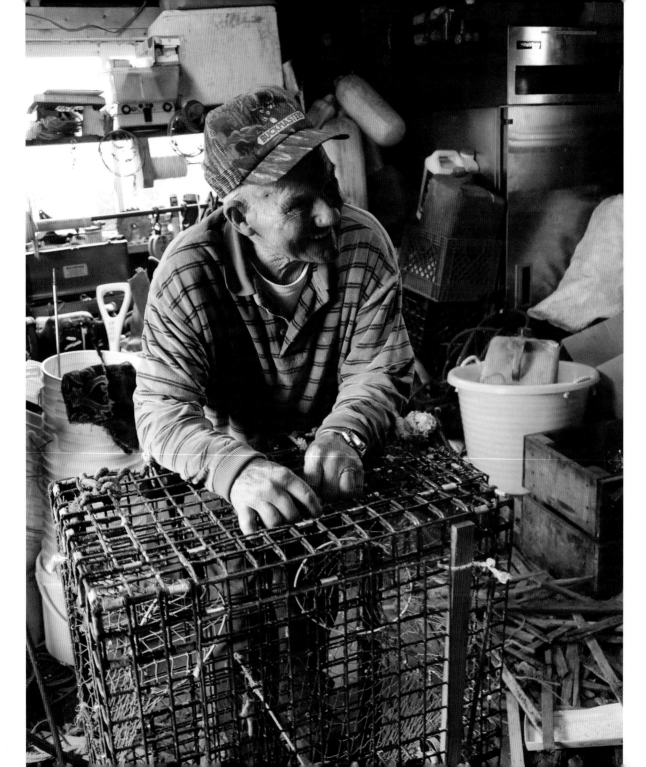

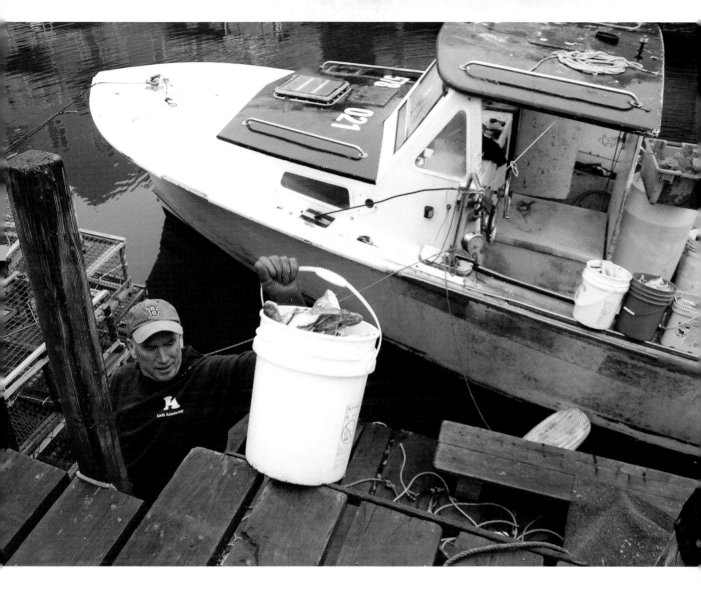

Left: Lobsterman David takes a break from repairing his trap, Portland *(Nance Trueworthy)*

Right. Loading bait to set the traps, Portland. *(Nance Trueworthy)*

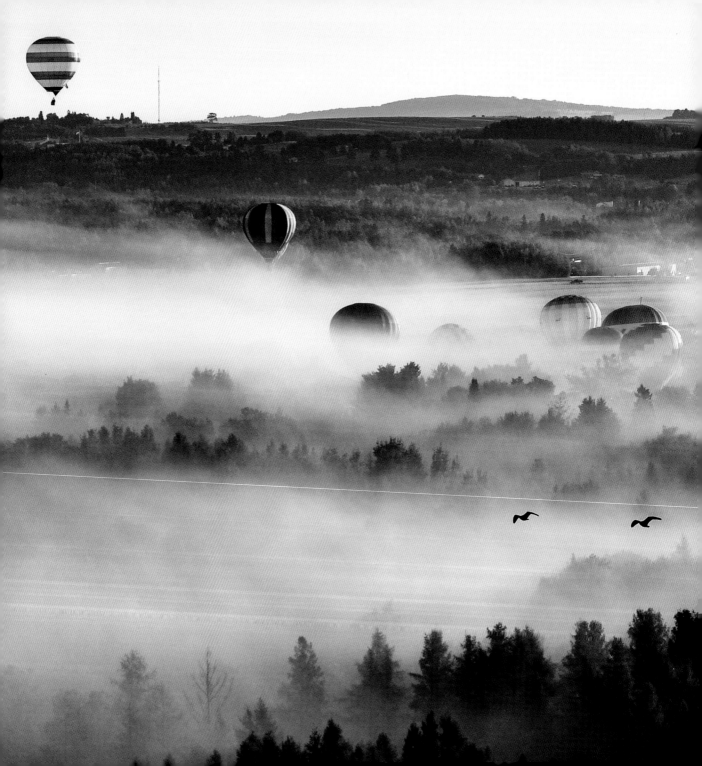

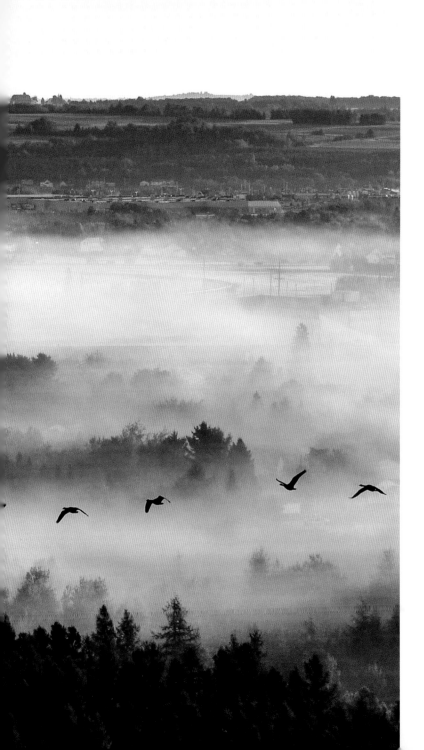

Morning launch at the Crown
of Maine Balloon Festival.
(Paul Cyr)

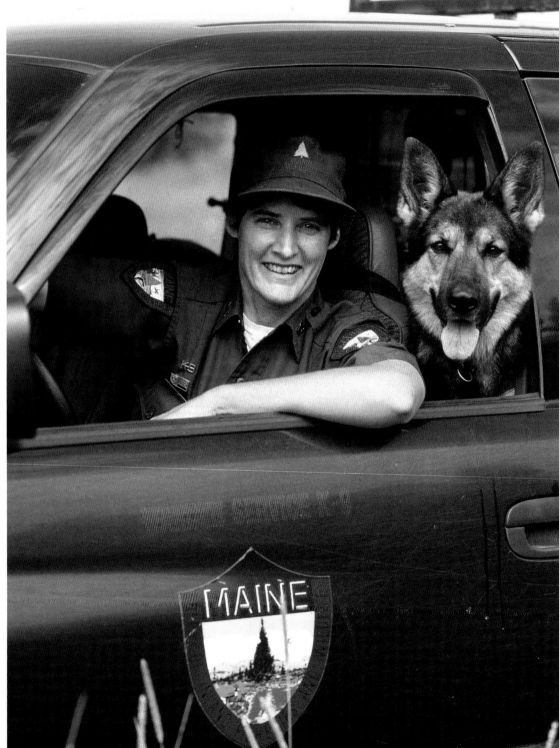

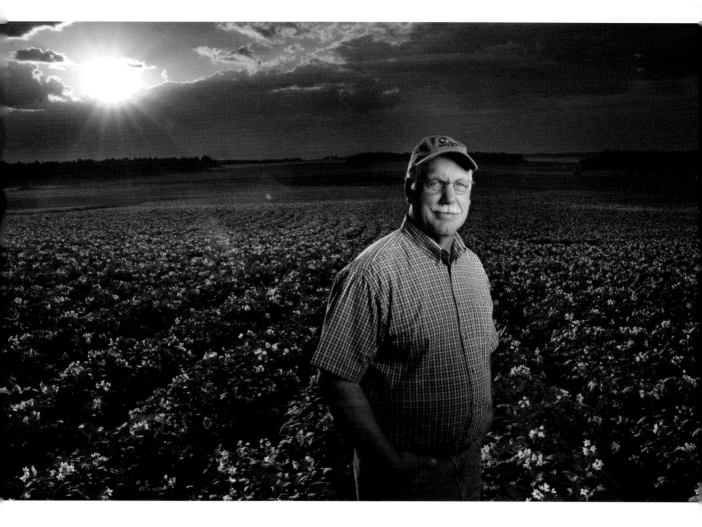

Left: Maine has the oldest game warden service in the country. Tasked with upholding fish and game laws in a state that is steeped in outdoors tradition and has the highest percentage of forestland, there's a lot to cover. Here, Warden Deb Palman pauses on patrol for a photo with her dog. *(Benjamin Magro)*

Right: Potato farmer Fred Flewelling stands in one of his Aroostook County potato fields in full blossom. *(Fred Field)*

What is my idea of Maine? A place where people let their neighbors be themselves—and accept them as they are.

—Tess Gerritsen, Camden

There's not much that's more quintessentially Maine than a
traditional lobster dinner. *(Malorie Nadeau)*

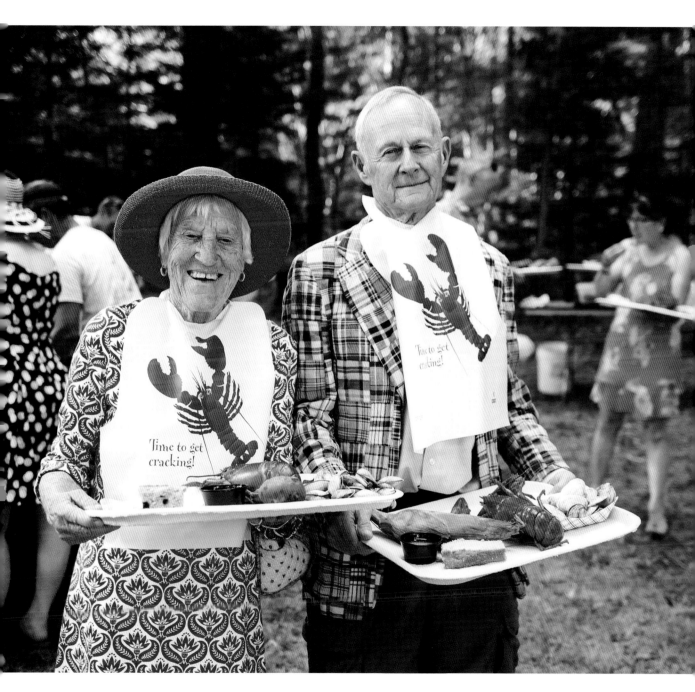

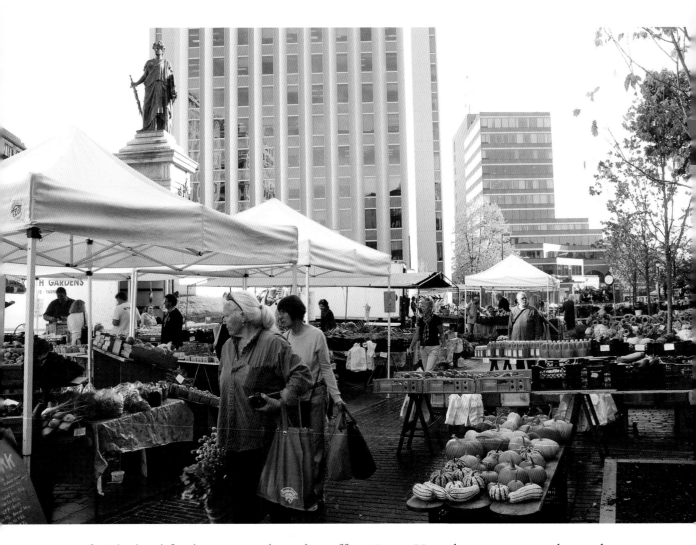

Left: The local-food movement has taken off in Maine. Here shoppers peruse the produce at the Portland Farmer's Market. *(Nance Trueworthy)*

Right: A father teaches his young son how to dig for clams in Scarborough. *(Nance Trueworthy)*

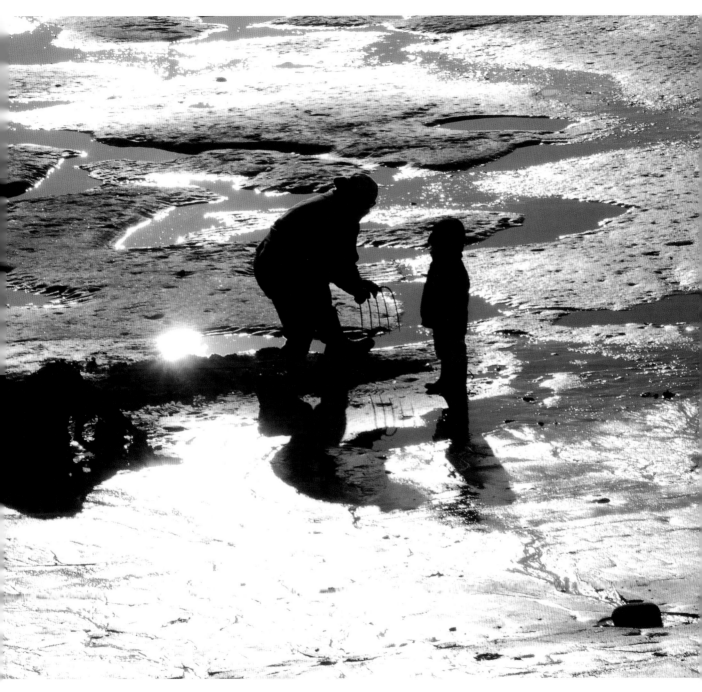

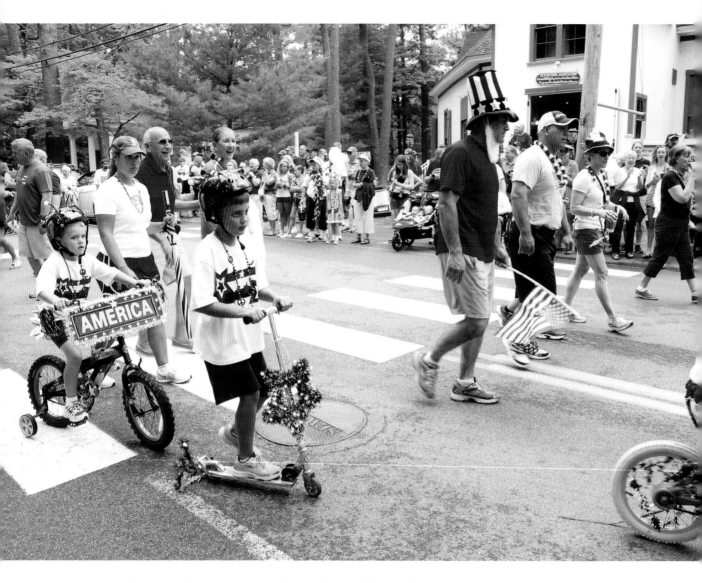

Left: Fourth of July parade in Ocean Park. *(Nance Trueworthy)*

Right: The salute, Memorial Day in Freeport. *(Kerry Michaels)*

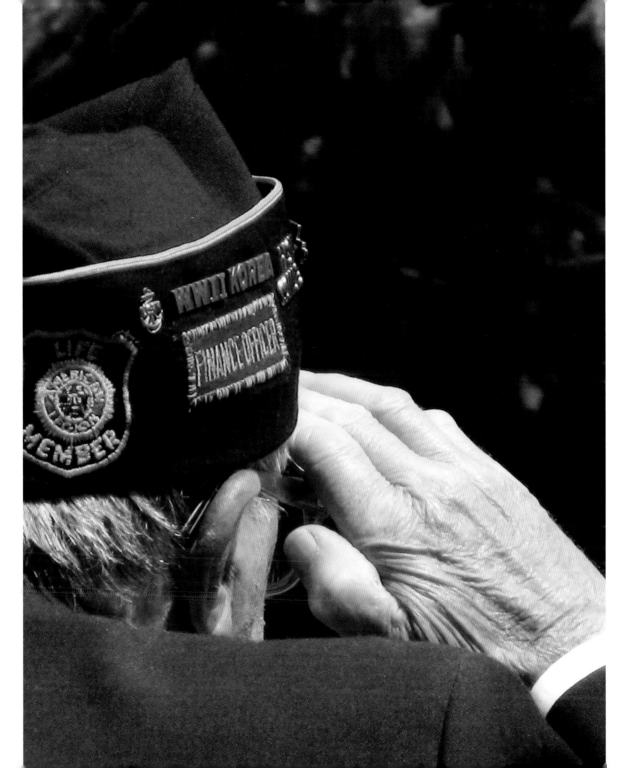

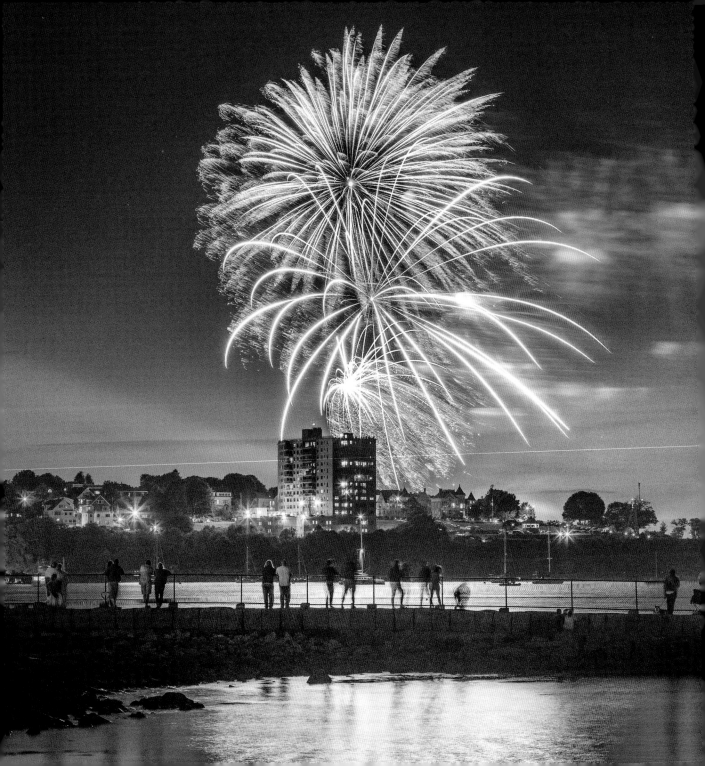

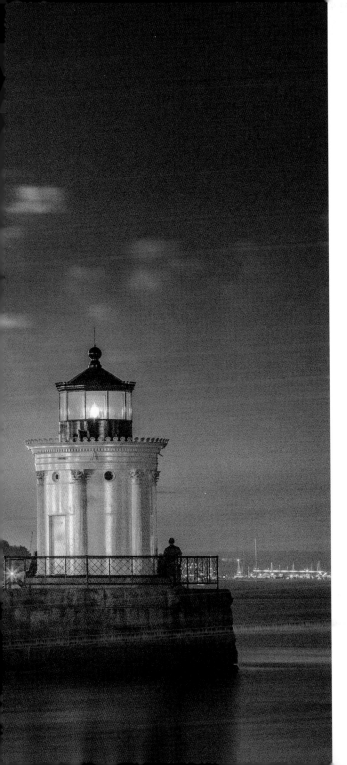

A small group of onlookers catches the show over Portland Harbor from Bug Light. *(Benjamin Williamson)*

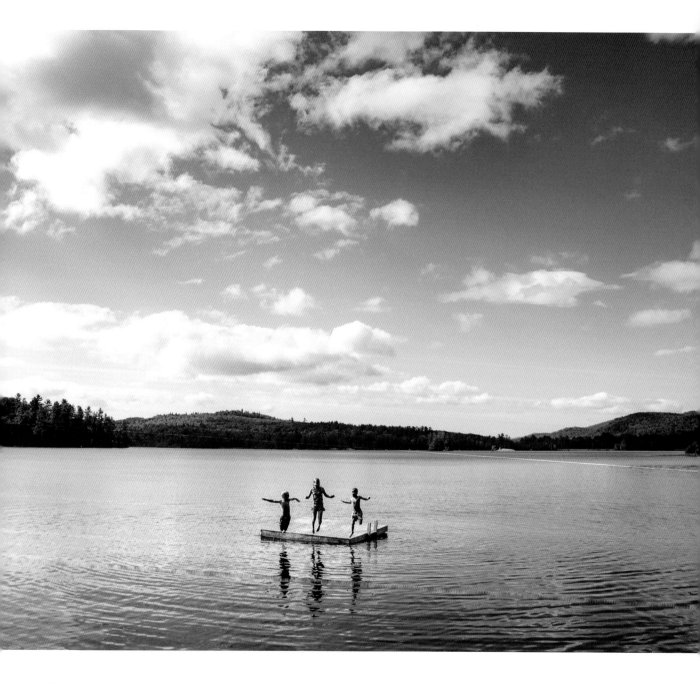

Maine is the welcome space inside you where you are always home, no matter where you are.

—Hannah Olson, Wiscasset

Summer in Maine means being on the water, in whatever form that takes. *(Heather Perry)*

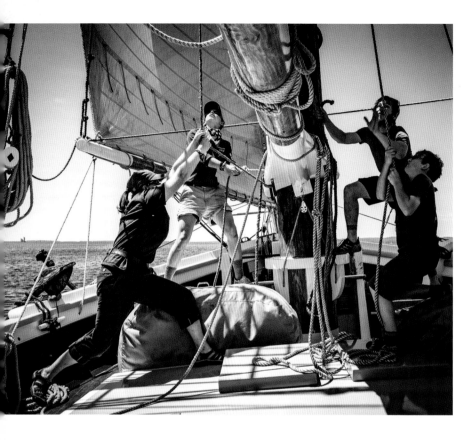

Left and right: Maine's schooner fleet is an important part of the state's maritime heritage. Windjammers are based from Bar Harbor to Boothbay and each summer the vessels play active roles in windjammer festivals, afternoon, day-, and multi-day sails, and the windjammer races, in which crews strut their stuff and prove who's the best. *(Jim Dugan)*

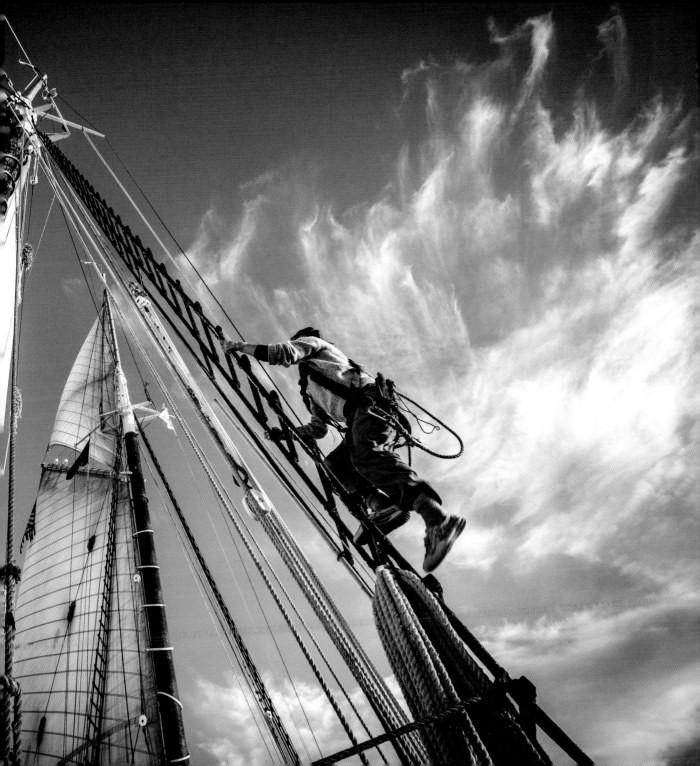

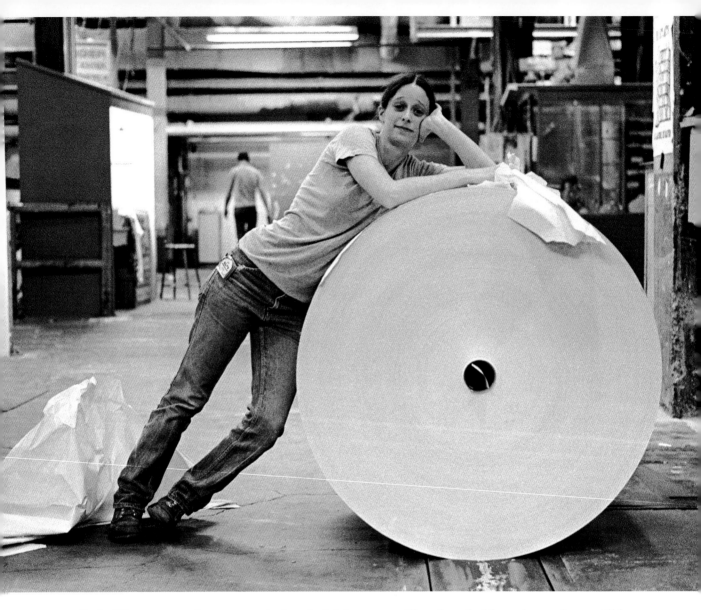

Left: The paper industry is in decline in Maine, yet millworkers hold out hope there will be a resurgence. Here, Lorraine Varraro enjoys a brief respite on her shift at the mill. *(Benjamin Magro)*

Right: A worker shapes pieces for a signature Thomas Moser chair.
(courtesy Thos. Moser Cabinetmakers)

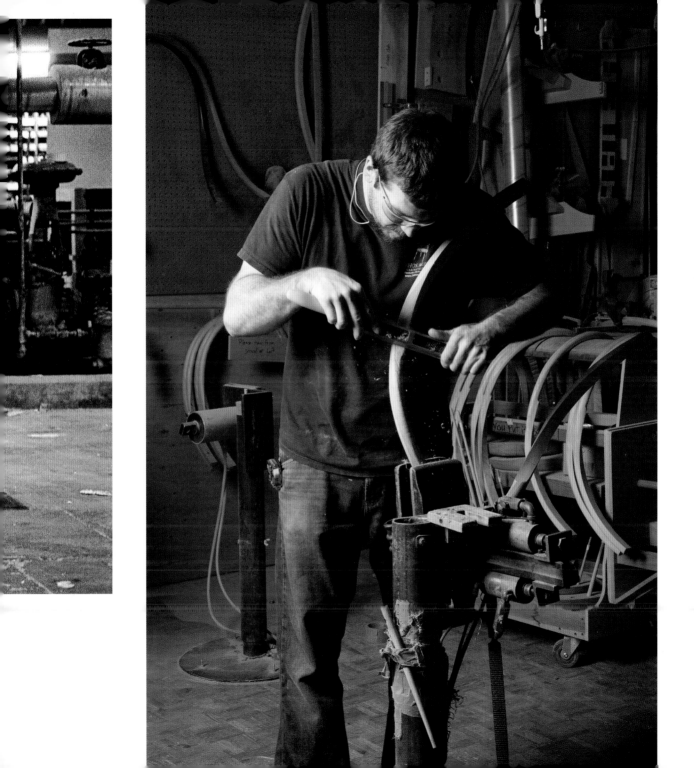

Machine operator Roy Bragg at work in the Wells Wood Turning and Finishing Company in Buckfield. One of the last of its kind in Maine, the company manufactures rolling pins, tool handles, toys, and other turned wood products. *(Jan Pieter van Voorst van Beest)*

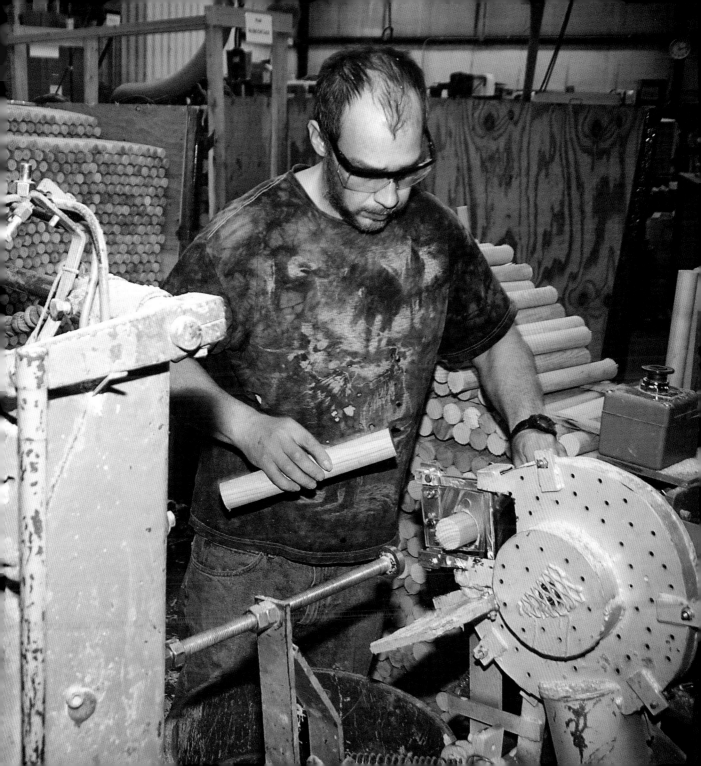

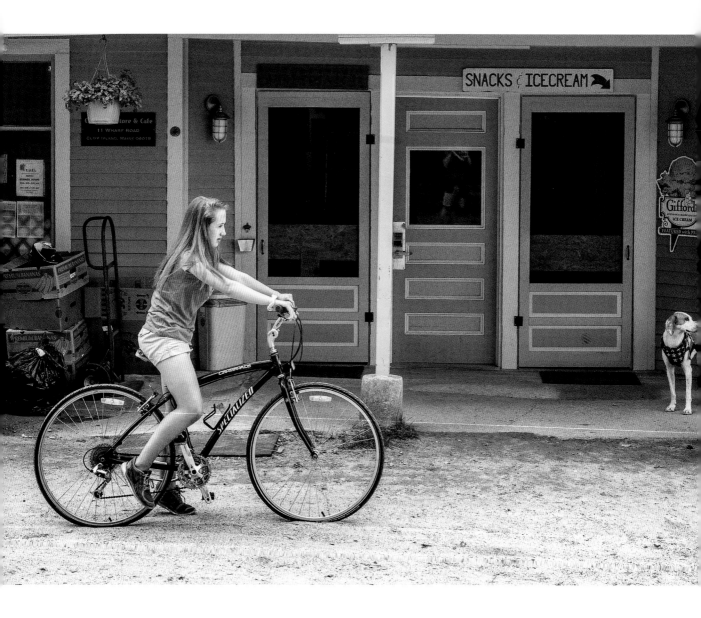

Maine is small towns and town meetings, people with wonderful wit and occasional brutal honesty, neighbors who have potlucks for each other when their houses burn down or they can't pay for cancer care, salty fishermen and stubborn farmers with kind hearts, cold winters and wood stoves, backyard gardens, creativity, incredible beauty, and a fierce love for your community and state.

—Hannah Pingree, North Haven

The store on Cliff Island, where life moves at its own pace.
(Benjamin Williamson)

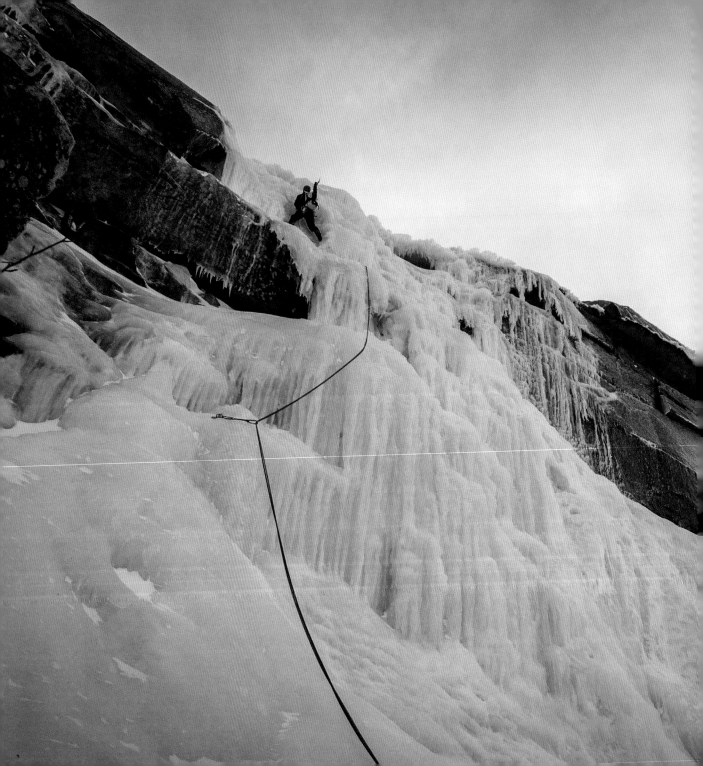

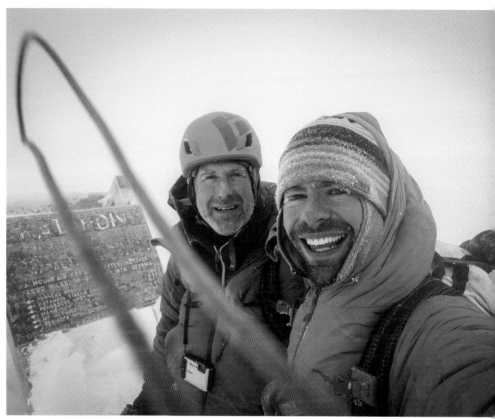

Left: Not for the unskilled or the faint of heart: winter climbing on Katahdin. Greg Bell ascends the beginning ice pitches above Chimney Pond. *(Brian Threlkeld)*

Right: On the summit in 60-plus mile-per-hour winds and zero visibility, Greg and photographer Brian Threlkeld (right) don't spend much time on top. *(Brian Threlkeld)*

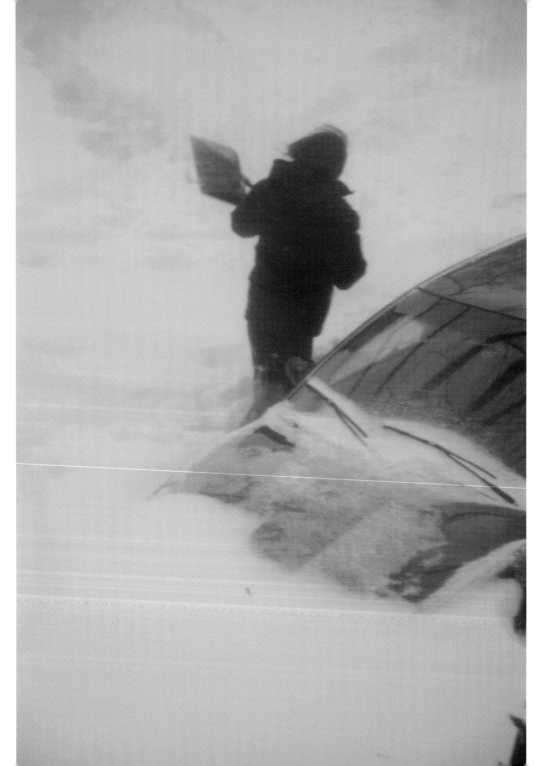

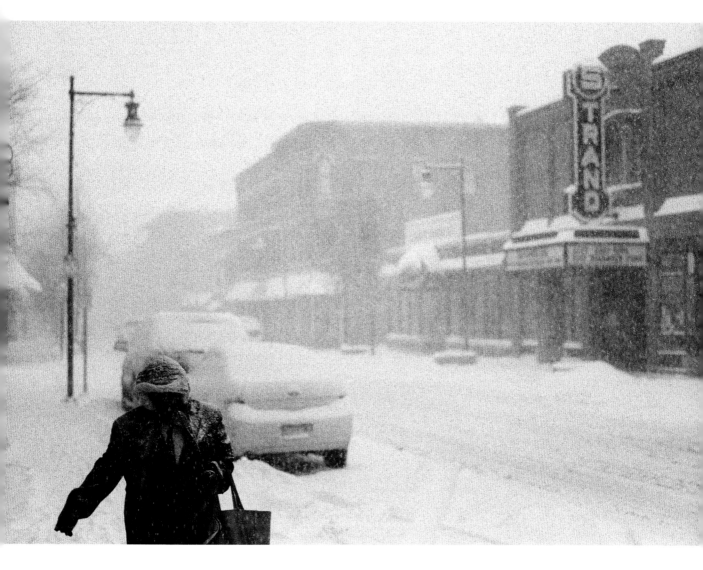

Left: Notorious for its winters, Maine drivers nevertheless know how to handle themselves in the snow. Here, a Portland resident shovels out during a storm. *(Nance Trueworthy)*

Right: And the snow doesn't always keep people from venturing out on foot either, like this pedestrian in Rockland. *(Johnny Patience)*

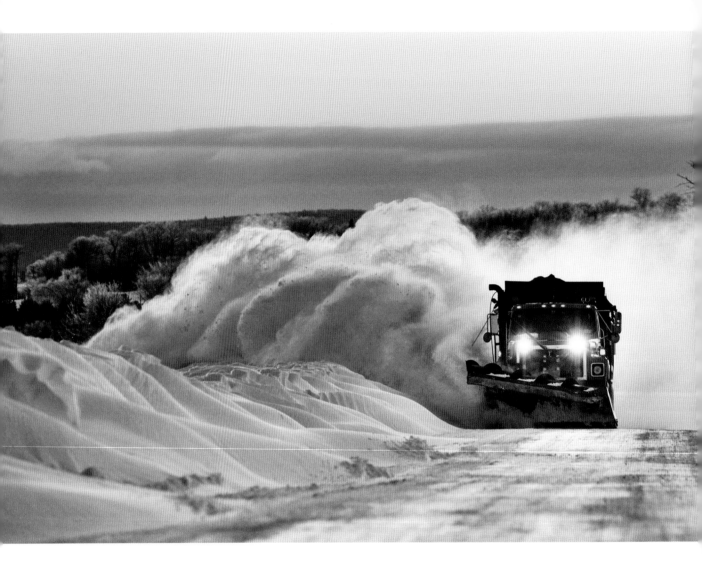

Left and right: The snowplow is a welcome sight to winter drivers. The plow drivers work long and exhausting shifts keeping the roads clear. *(Paul Cyr)*

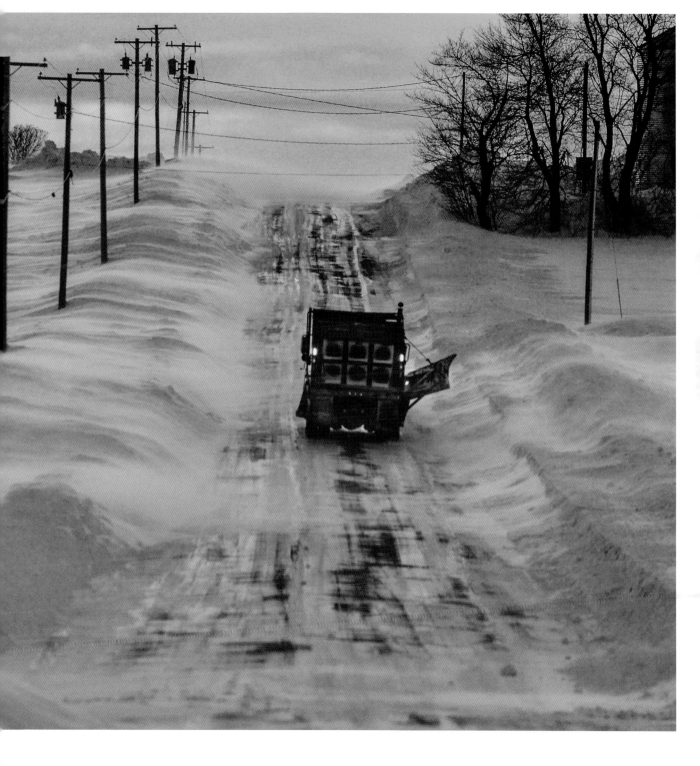

Walking up from the barn after chores into my grandparents'
kitchen, redolent of leftover ham, onions, and bacon sizzling in a
cast iron skillet on top of the Palace Crawford as biscuits bake within.
It's ten below zero at 4 p.m., no wind, and dark as a pocket.
Grandpa says to Grammy, "Pleasant day, deah."
She sighs, "Ayuh."

—Anne York Agan, North Ferrisburg, Vermont

Cutting new holes for ice fishing. *(Paul Cyr)*

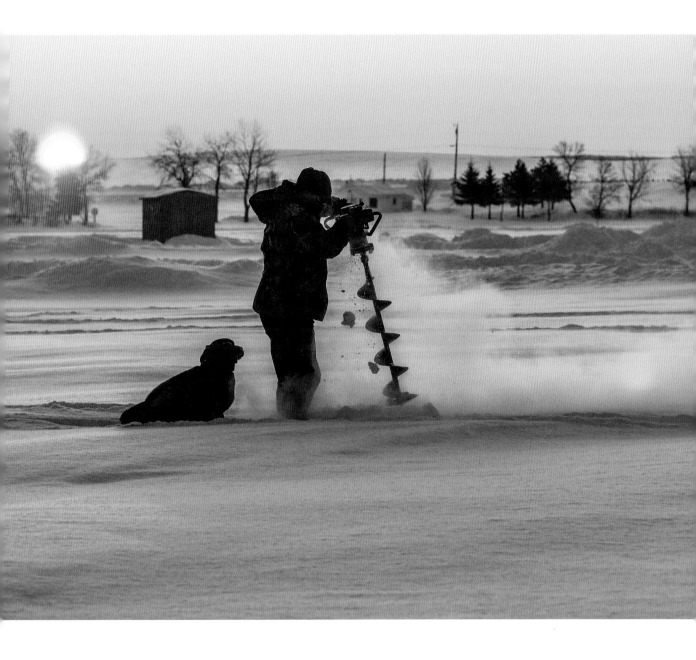

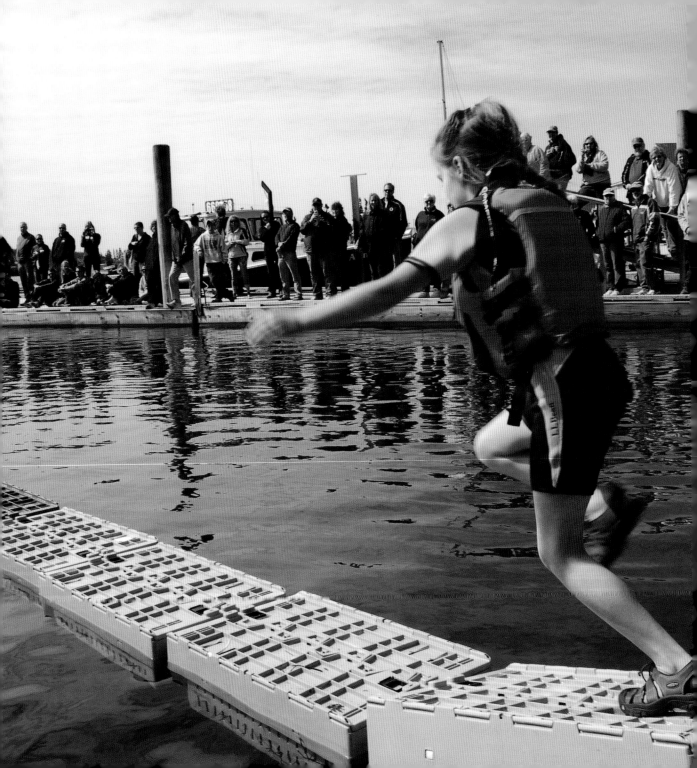

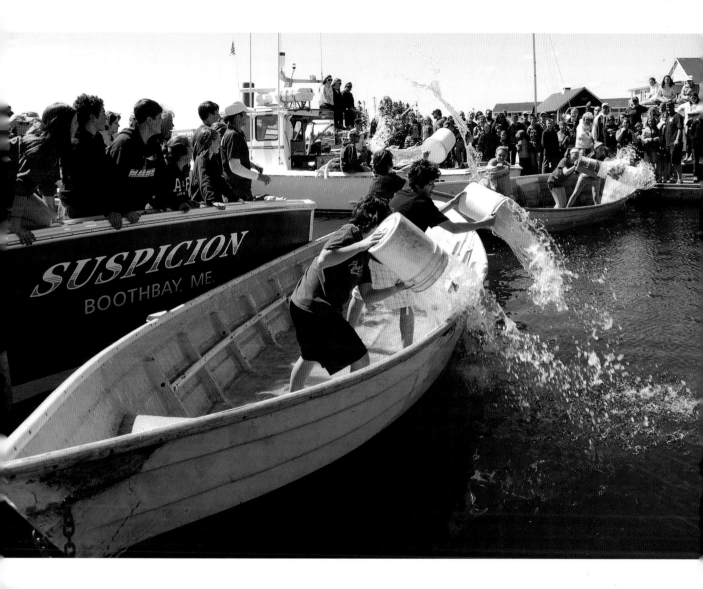

Left and right: With events including lobster crate races (left) and dory bailing contests (right) The Fishermen's Festival in Boothbay always kicks off the summer with a splash. *(Nance Trueworthy)*

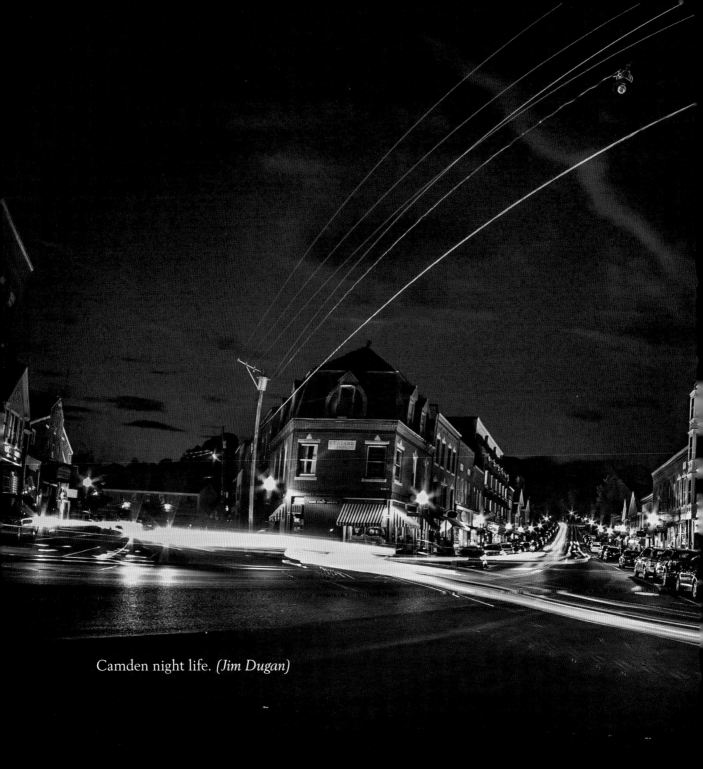

Camden night life. *(Jim Dugan)*

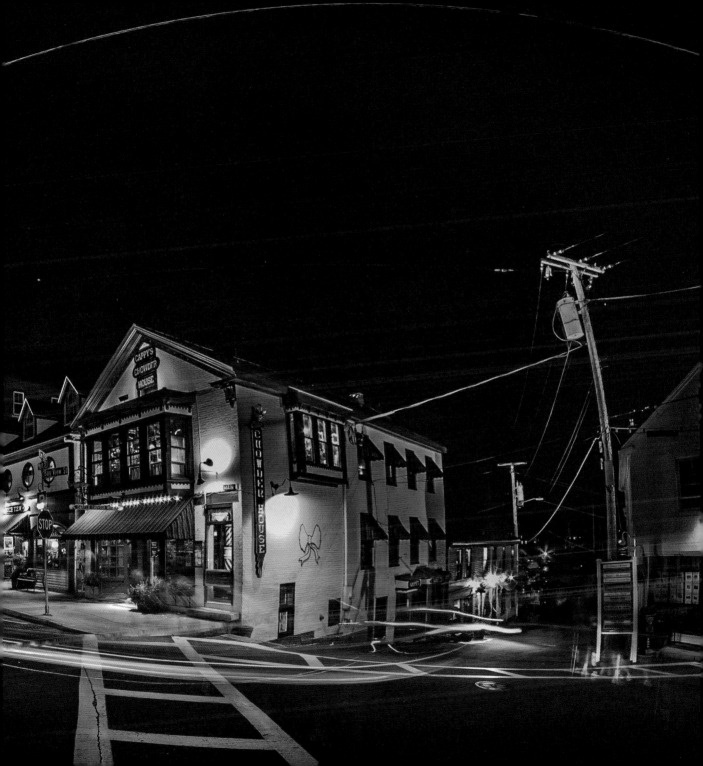

Left: Project Puffin researcher Kelsey Navarre searches a nest for puffin chicks on Eastern Egg Rock in outer Muscongus Bay. *(Fred Field)*

Right: Navarre with the first puffin chick of the season to be caught, weighed, and evaluated on Eastern Egg Rock. *(Fred Field)*

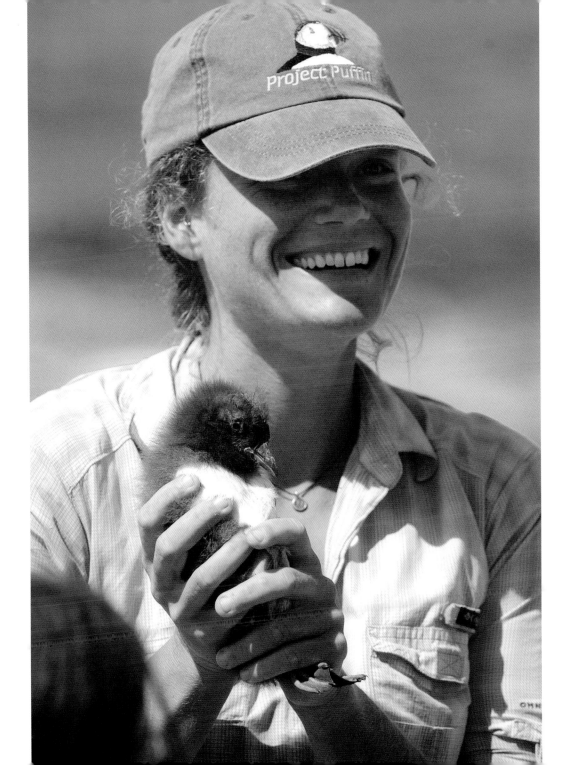

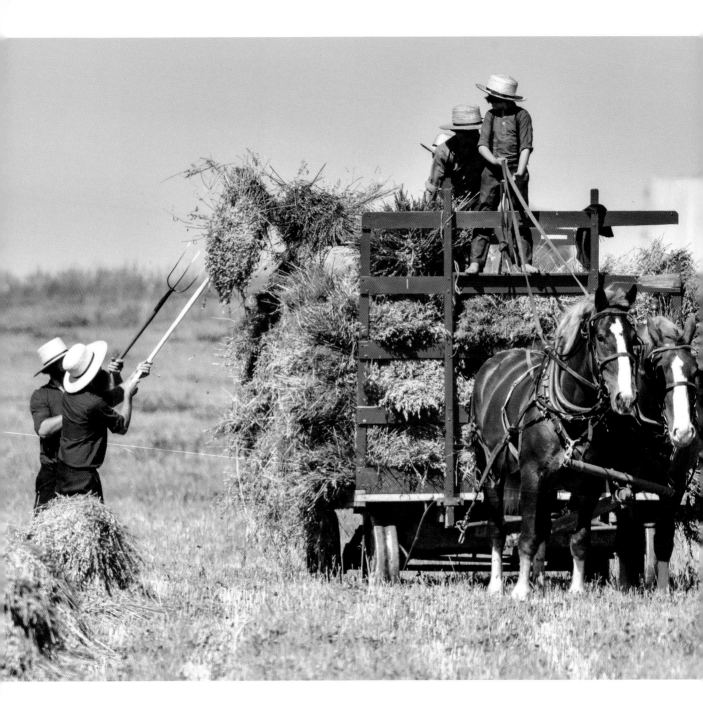

Collecting pay from the farmer whose hay you helped get in involves driving by the place for several months until you see him out in the dooryard so you can ask, "Don't s'pose you owe me any money, do ya?"

He would probably answer, "Mos' probly."

—John Nichols, Winthrop

Maine's Amish eschew most modern technologies, relying on old fashioned manpower to get the job done. *(Paul Cyr)*

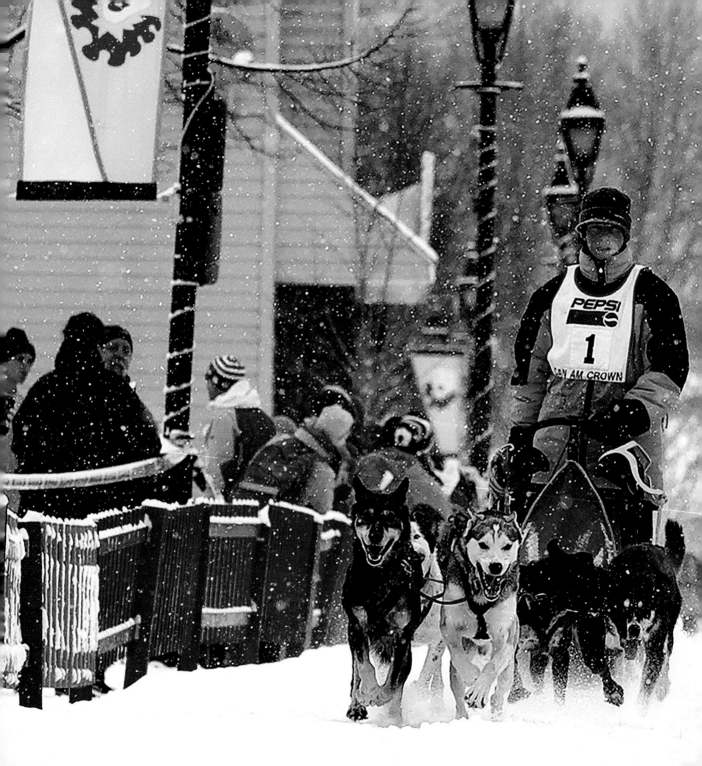

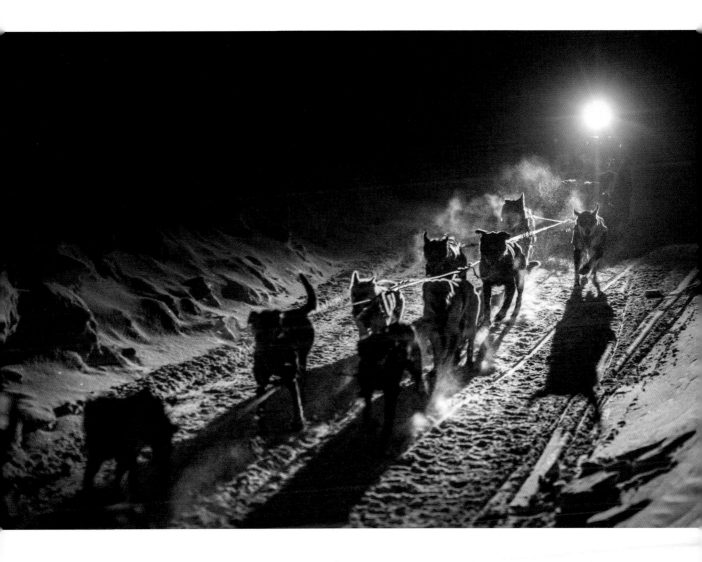

Left and right: The 250-mile course for the Can-Am Crown International Dog Sled Races starts in Fort Kent. This race is a step for mushers on the road to the Iditarod. *(L: Dan Tobyne, R: Paul Cyr)*

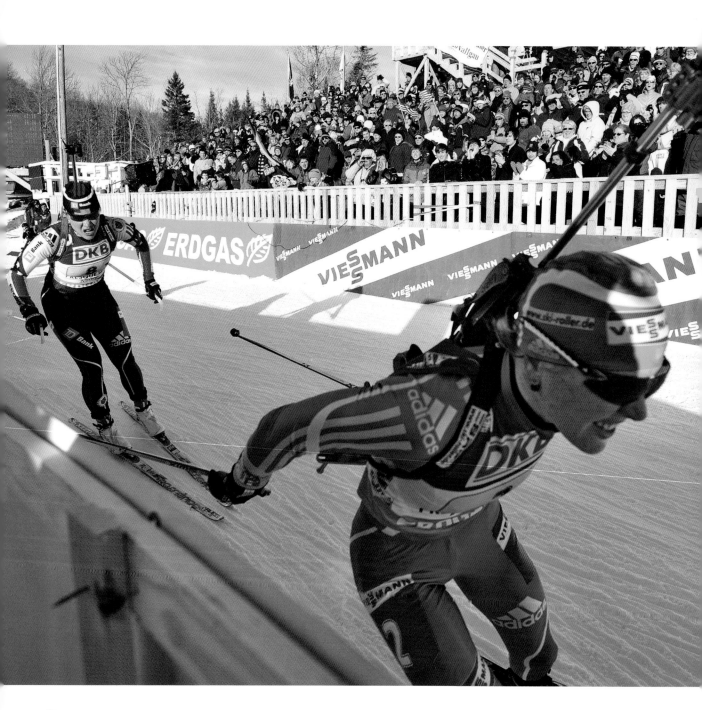

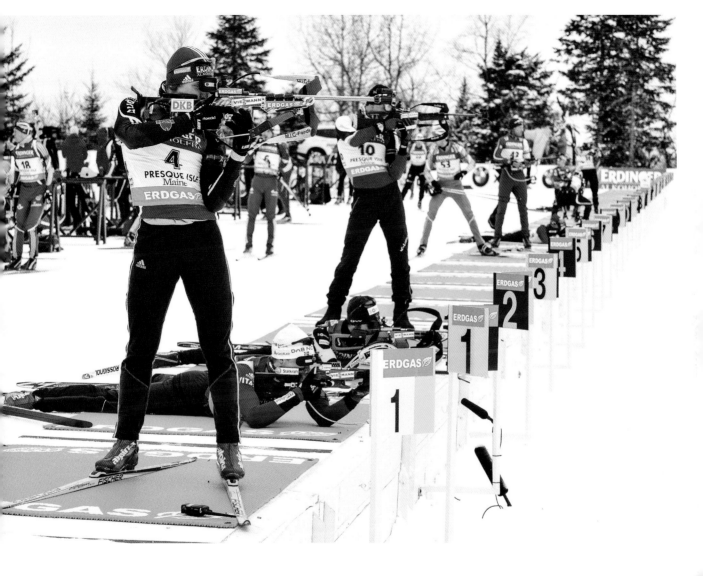

Left and right: Olympics-bound biathletes from around the world compete in a combination of cross-country skiing and marksmanship in the Biathlon World Cup at Presque Isle's Nordic Heritage Center. *(Paul Cyr)*

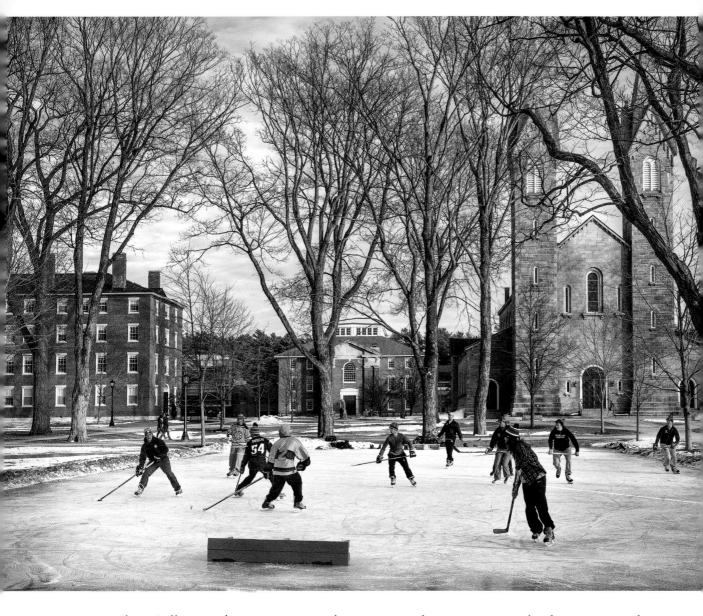

Bowdoin College students enjoy some down time with an impromptu hockey game on the quad. *(Benjamin Williamson)*

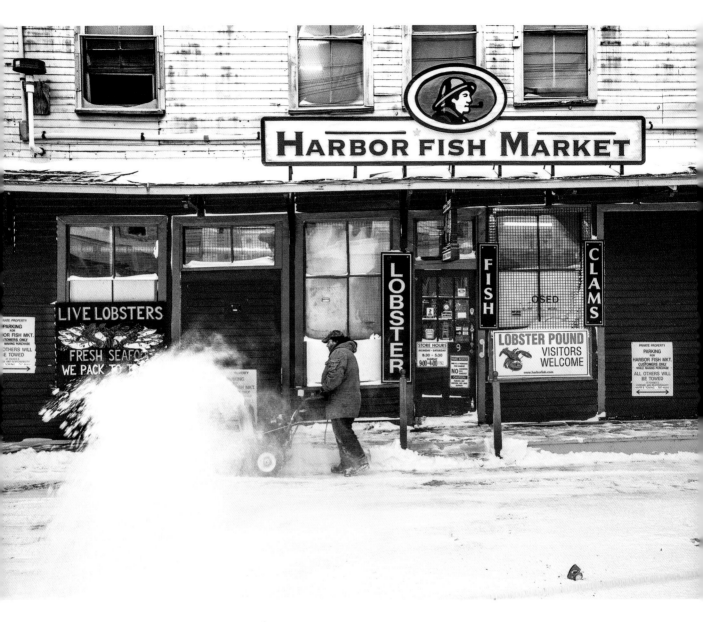

Clearing out in front of Portland's Harbor Fish Market. *(Benjamin Williamson)*

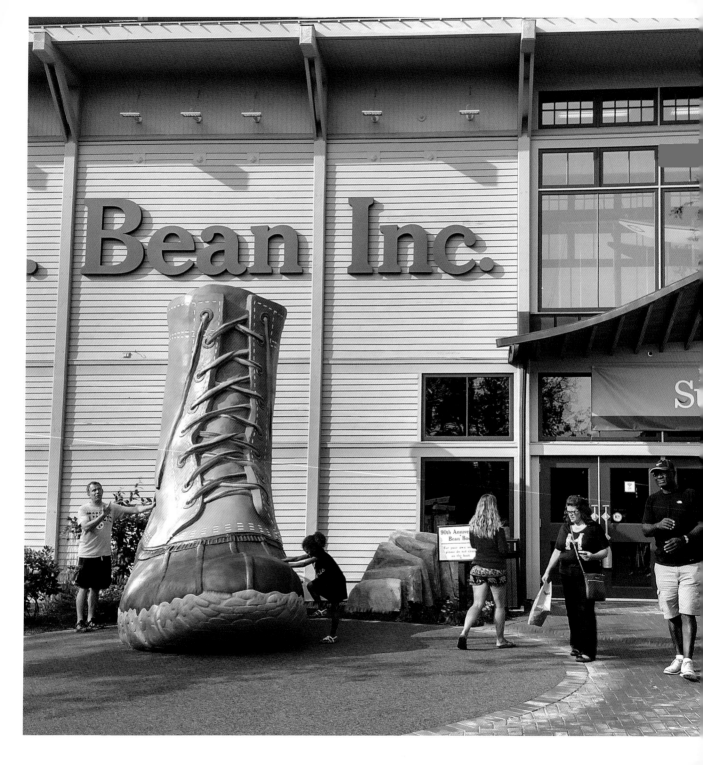

Maine can be summed up in one word: Boots. Hiking boots to the north, garden boots to the west, fishing boots to the east, and practical, sometimes stylish, sloppy weather boots to the south. And all over Maine you must be able to step out of your boots when you come in the back door at suppertime.

—Mary Ellen Kelleher, Rockland

L.L. Bean's flagship store in Freeport honors its most iconic product with a giant replica Maine Hunting Shoe. According to company officials, if it were a real boot it would be size 410. *(Dan Tobyne)*

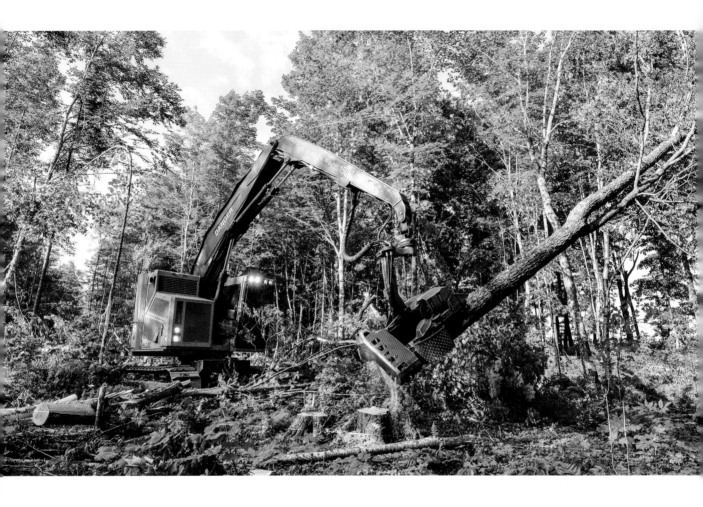

Left and right: Maine's extensive forest industry supplies wood for lumber, paper, firewood and wood pellets, even biomass for generating electricty; and it provides jobs. *(Paul Cyr)*

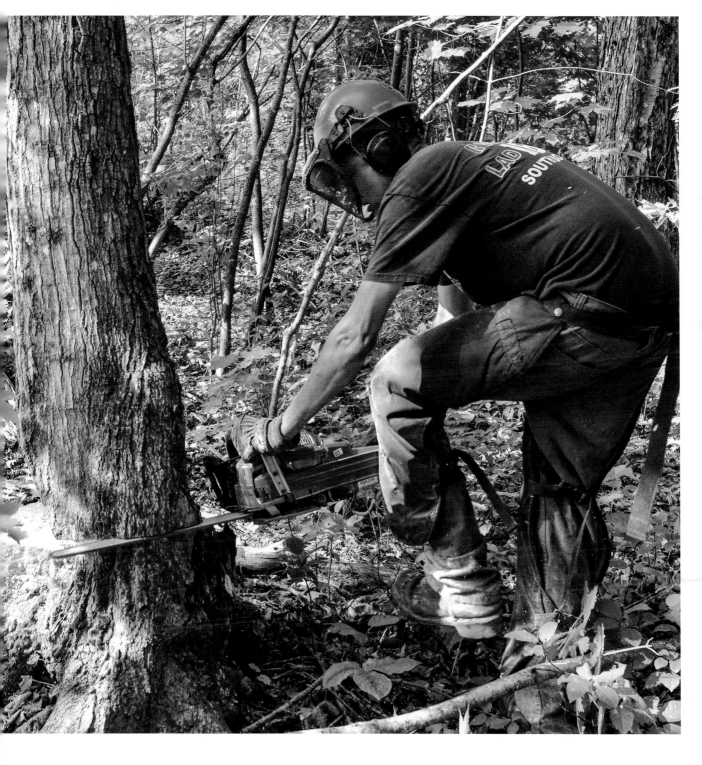

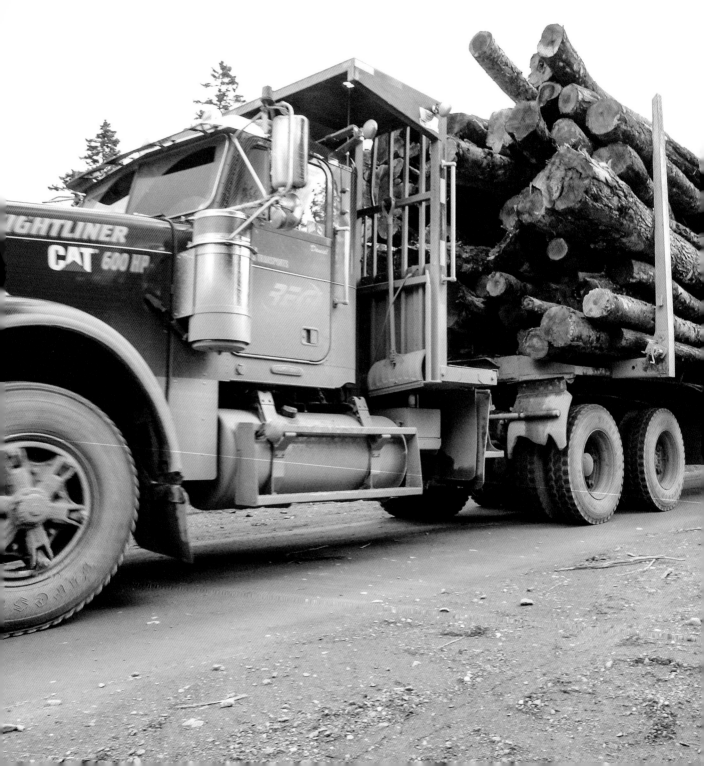

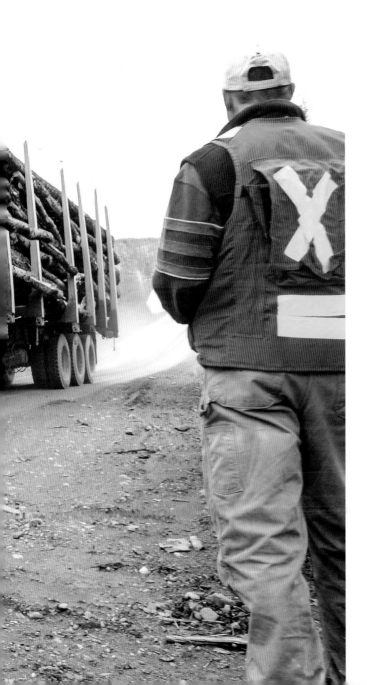

King of the road. In the North Woods, these log haulers have the right of way. Here one rolls into the yard to drop off a load. *(Paul Cyr)*

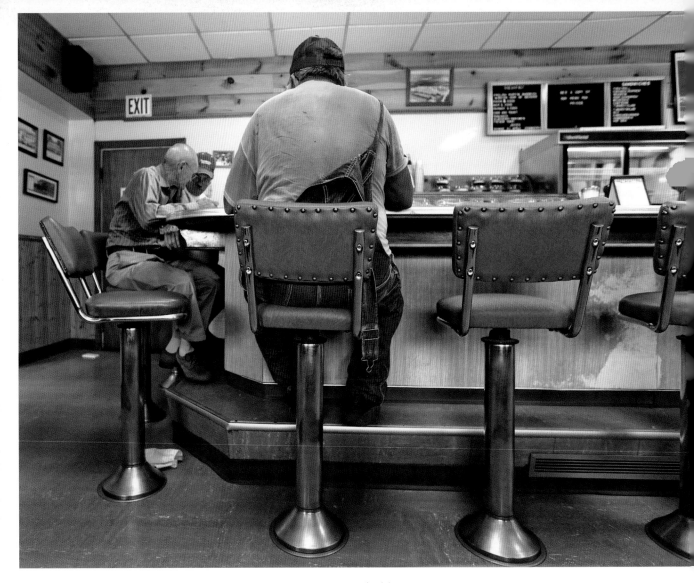

Left: Moody's Diner in Waldoboro has provided homestyle meals to local regulars and tourists passing through for more than eighty years. (*Dan Tobyne*)

Right: Mainers young and old love Moxie. Every spring the town of Lisbon's Moxie Festival celebrates the soda with the distintive flavor. (*Dan Tobyne*)

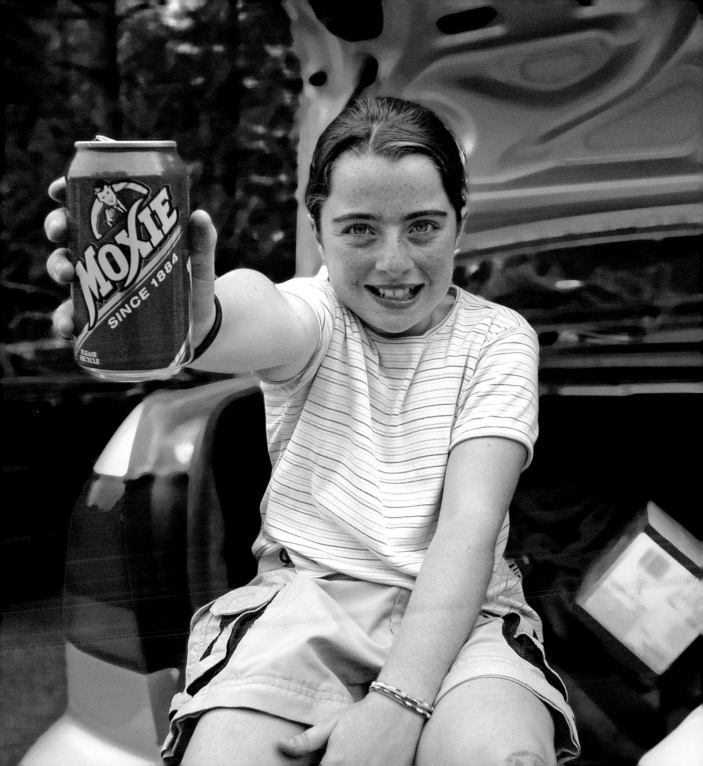

I put my faith in the ingenuity of Mainers to teach the rest of us Americans what it means to earn an honest living, live a modest life, and recognize the meaning of the word "enough."

—Penny Zokaie, Cross River, New York

Bait handler Larry Skillins of Portland lights a cigarette during a brief break between loading lobster boats in Portland harbor shortly after sunrise. *(Fred Field)*

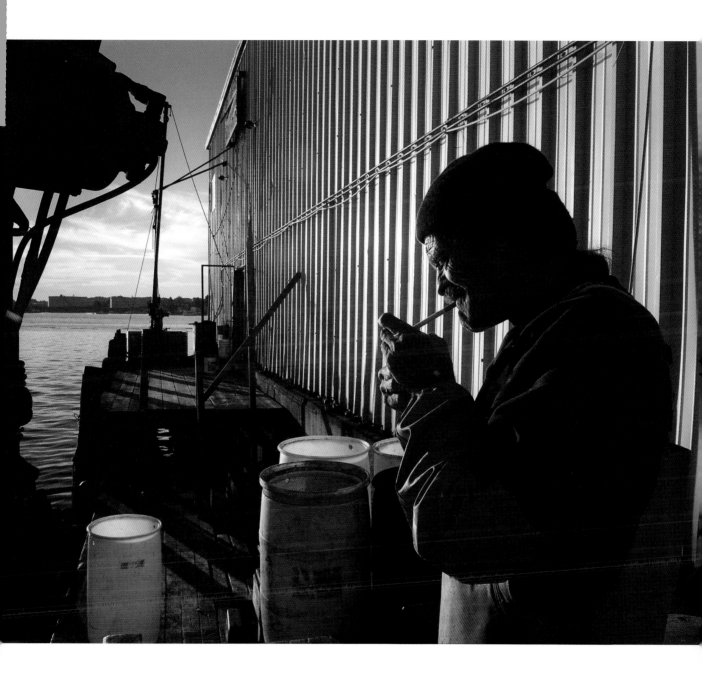

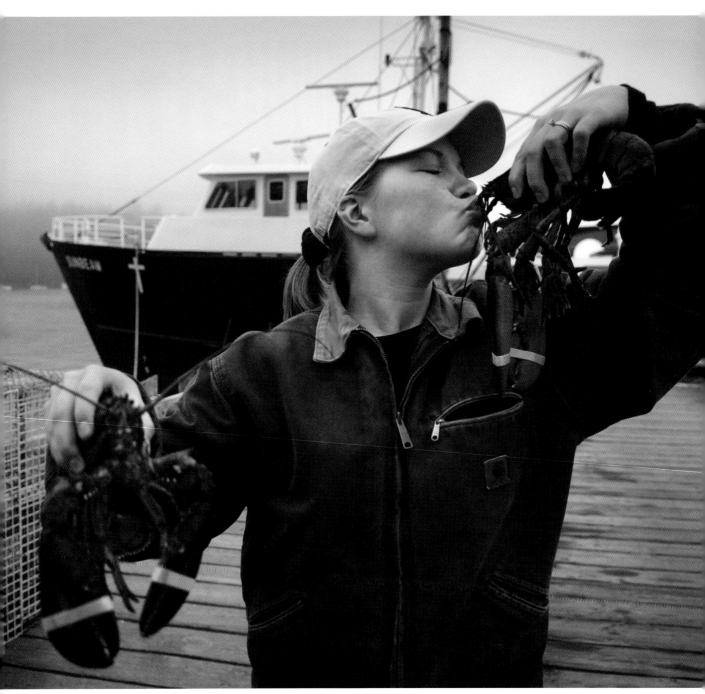

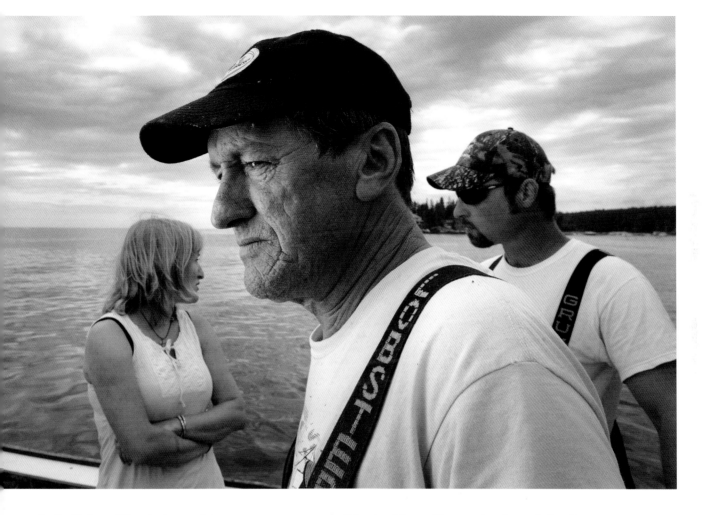

Left: Felicia Bland gives a kiss to a crustacean on Isle Au Haut. She works aboard the *Sunbeam V*, the outreach vessell for the Maine Seacoast Mission Society. *(Fred Field)*

Right: Lobsterman Jim McMahan of Georgetown says he's not yet concerned about occasional unwanted sea bass from the mid-Atlantic that end up in his traps. His daughter, however, researcher Marissa McMahan, left, is concerned. With climate change, sea bass have made their way north into Maine's southern waters. The potential exists that the fish will adversely impact Maine's lobster industry. *(Fred Field)*

Small barbershops like Doug's in Rockland can be found all over Maine. In addition to providing modestly priced haircuts, they often act as community hubs, where regulars gather to hear and share local news. *(Johnny Patience)*

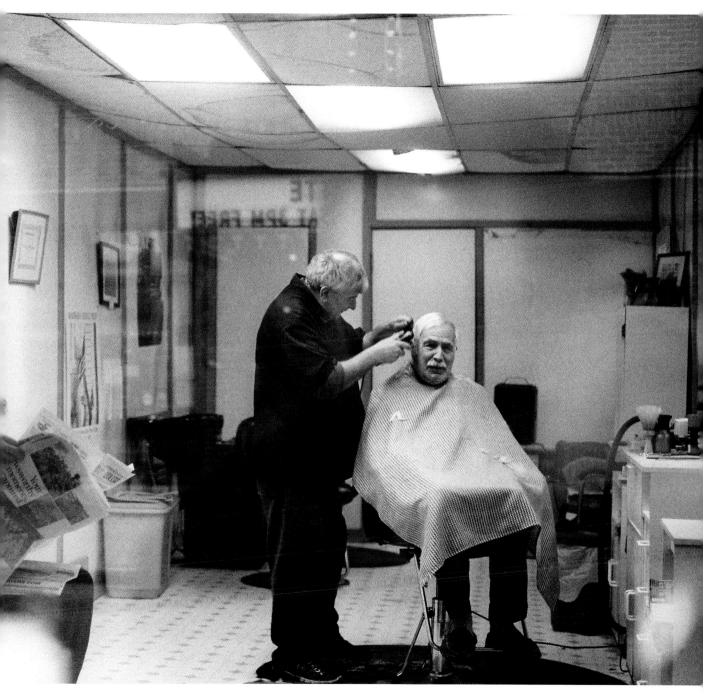

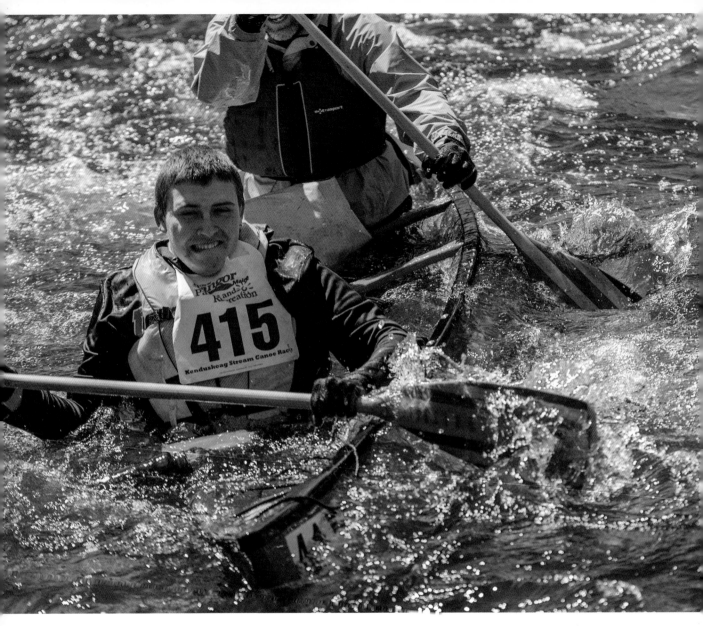

Every spring intrepid paddlers take on the Kenduskeag Stream Canoe Race. The race takes place in April shortly after ice-out when the stream is rushing with frigid snowmelt. *(Jim Dugan)*

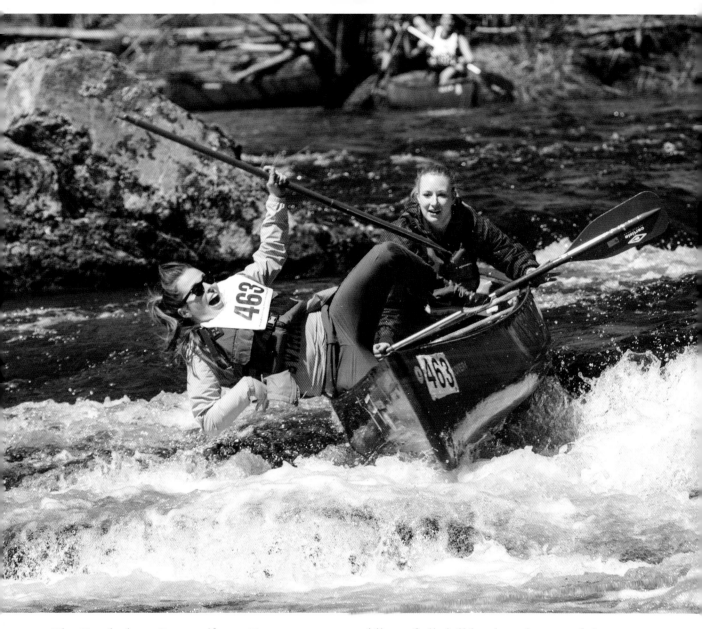

The Kenduskeag Stream Canoe Race is open to paddlers of all skill levels and many of them lose it in the swollen stream. This paddler has decided that if she's going over, she's at least going over in style. *(Jim Dugan)*

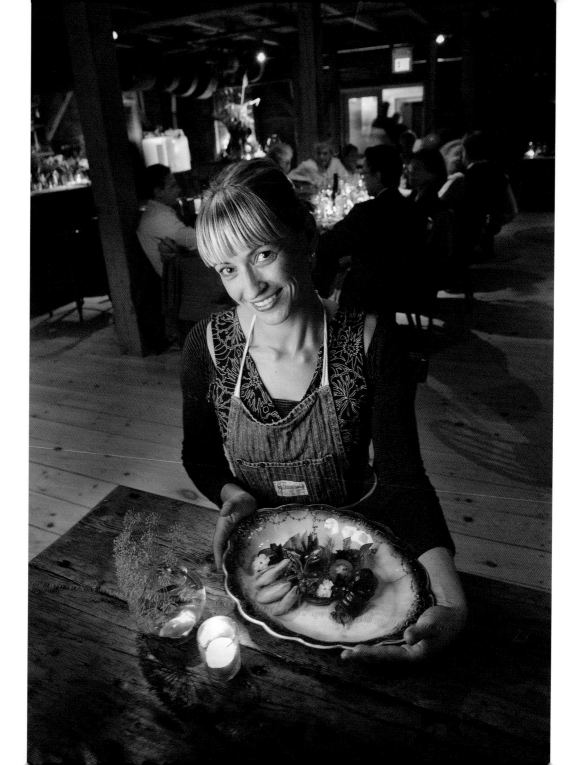

People who have roots in Maine never leave and if they do, they come back. Why is no secret if you have ever lived here.

—Sonny Perkins, Houston, Texas

Erin French at her wildly popular restaurant, The Lost Kitchen, in Freedom, which she opened after giving up a culinary career in New York and moving back home. When she recently began accepting reservations for the summer season she received close to 10,000 calls in 24 hours. *(Fred Field)*

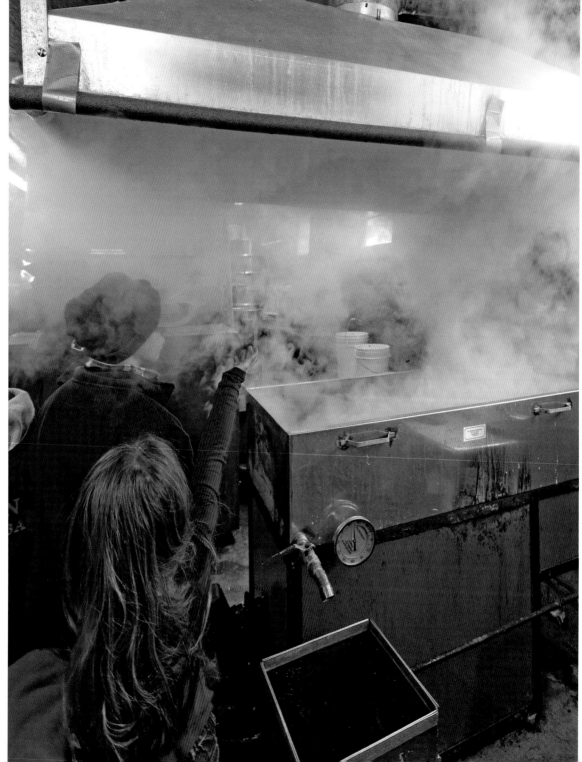

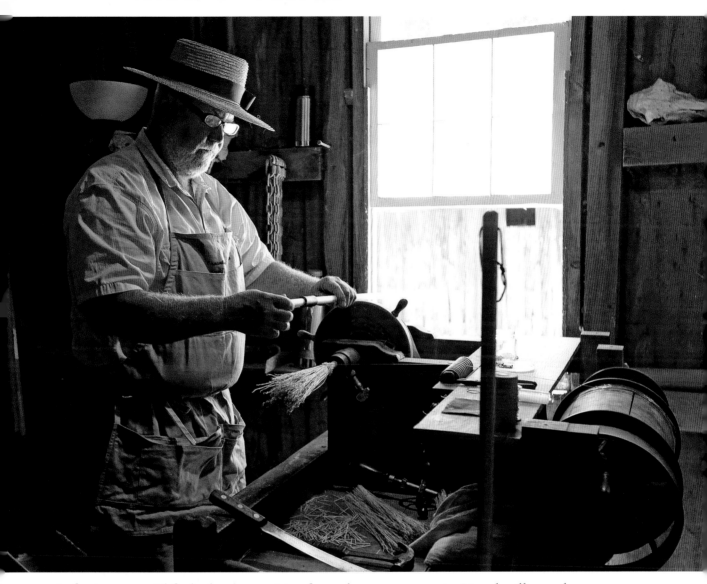

Left: A young girl feels the steam rising from the evaporator at a Lincolnville maple sugar shack. *(Dan Tobyne)*

Right: The Shaker community at Sabbathday Lake is the last of its kind in the country. Here, one of the Friends of the Shakers demonstrates the age-old method of making a broom. *(Dan Tobyne)*

Yule hauling ice from Whipple Pond in rural
Somerset County. Yule and his family harvest
ice from the pond every winter and store the
large blocks in sawdust, where it stays frozen
well into the summer. *(Keliy Anderson-Staley)*

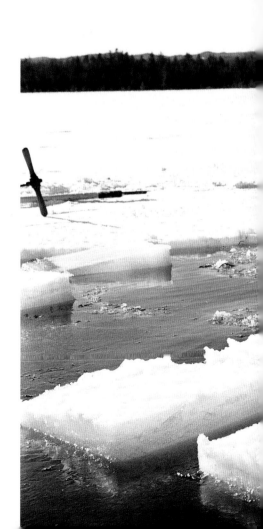

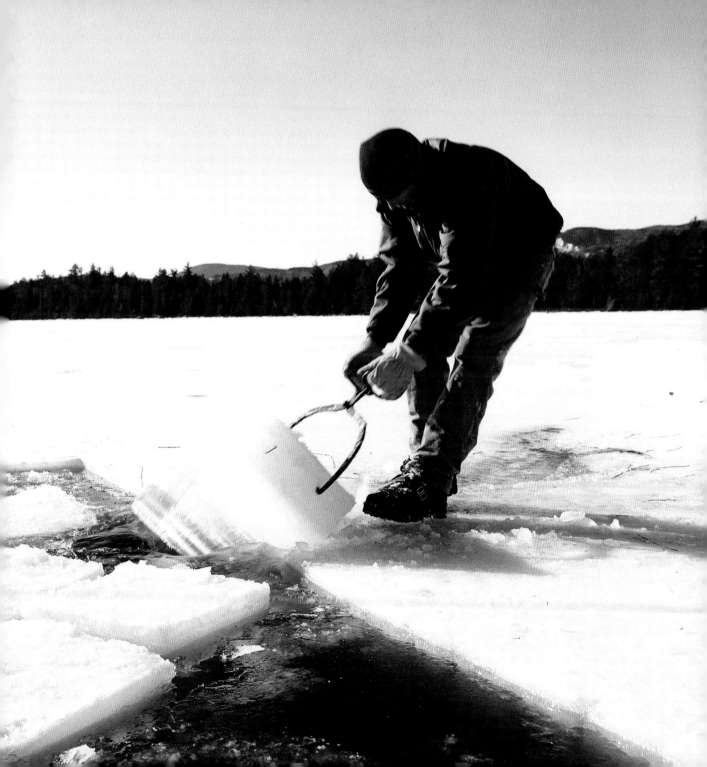

Digging out the beans for an old fashioned bean-hole bean supper at the Patten Lumberman's Museum. The beans are baked over hot coals buried in the ground. *(Dan Tobyne)*

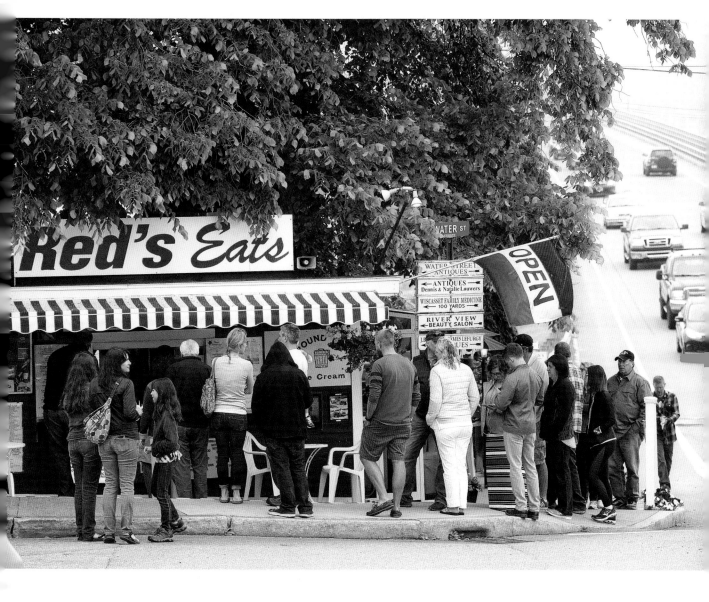

Red's Eats in Wiscasset is nearly as well known for its long lines as it is for its famous lobster roll. *(Dan Tobyne)*

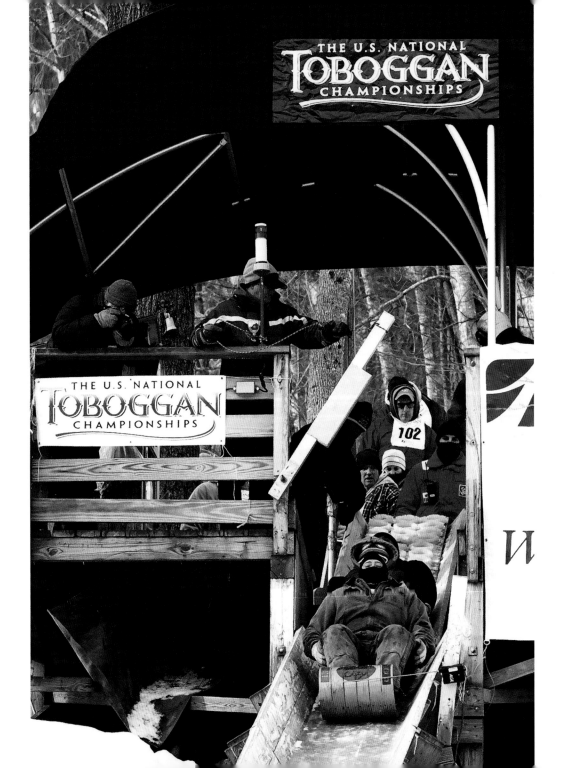

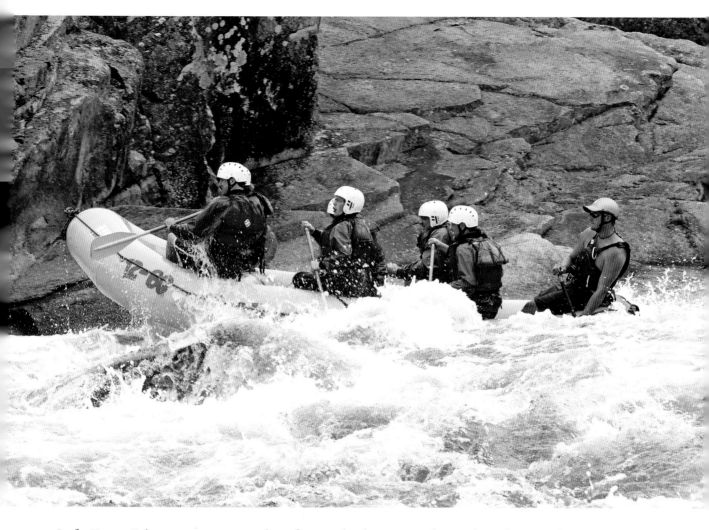

Left: Every February amateur and professional tobogganers descend on the Camden Snow Bowl for the National Toboggan Championships. While teams do vie for the fastest times down the 400 foot chute, fun is the order of the day. *(Dan Tobyne)*

Right: Whitewater rafting on the Dead River, led by a Registered Maine Guide. *(Dan Tobyne)*

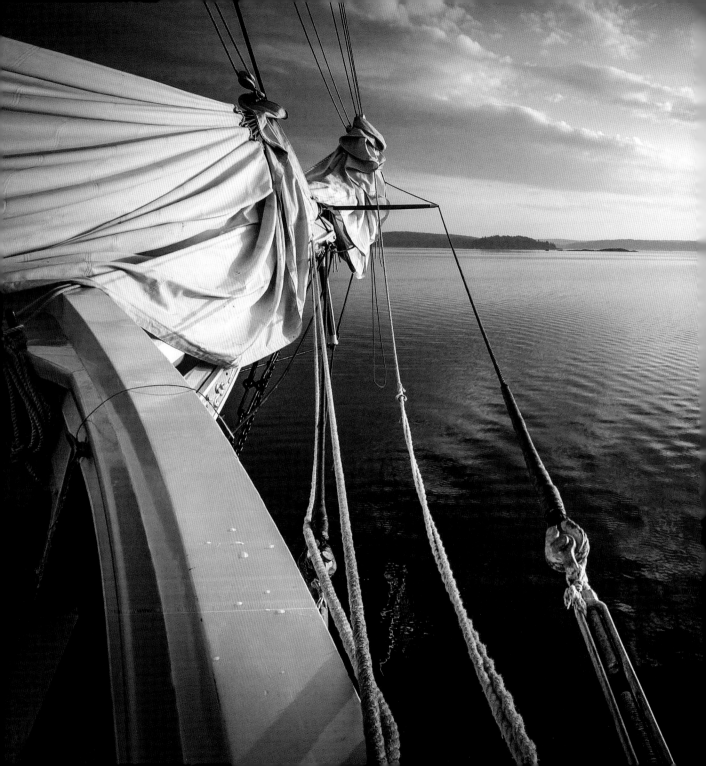

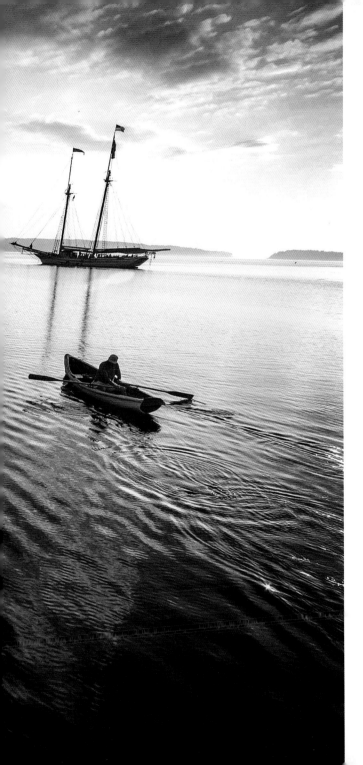

Morning commute for a schooner captain, Rockland Harbor. *(Jim Dugan)*

I like to think of Maine as a place that is ten years behind the times and twenty years ahead of the rest of the country. It's a ruggedly beautiful place where people have to work hard. We appreciate what we have and those we share it with.

—Bill Green, Cumberland

Oyster harvester Eric Horne of South Freeport is focused on navigating as he heads out toward one of his oyster beds in the low predawn light. *(Fred Field)*

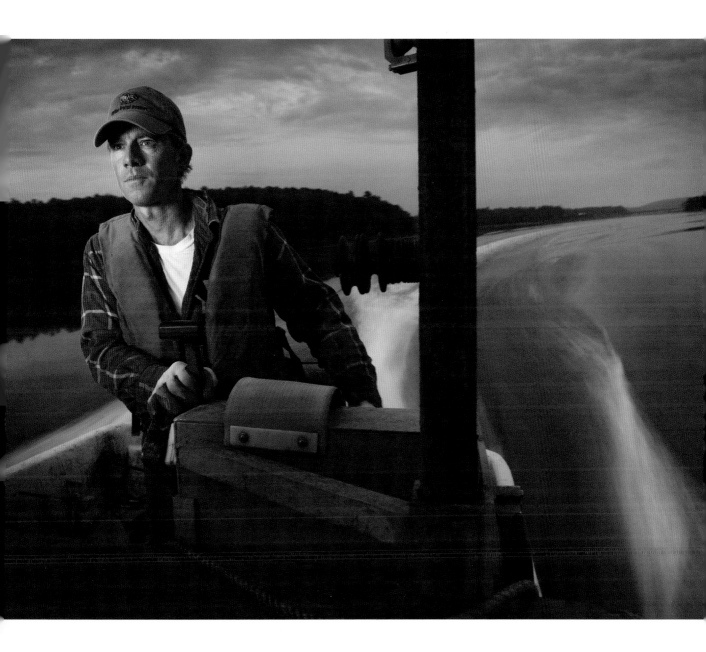

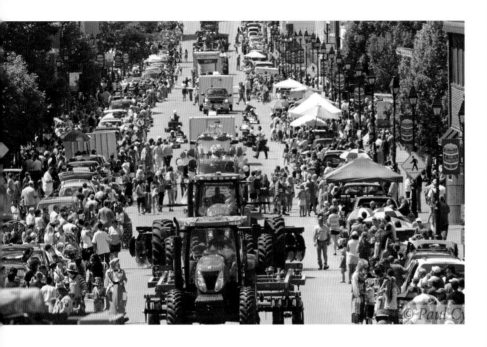

Left: The parade during friendly Fort Fairfield's annual nine-day Maine Potato Blossom Festival *(Dan Tobyne)*

Right: Crowds throng the sidewalks near the Maine College of Art during one of Portland's First Friday Art Walks. *(Dan Tobyne)*

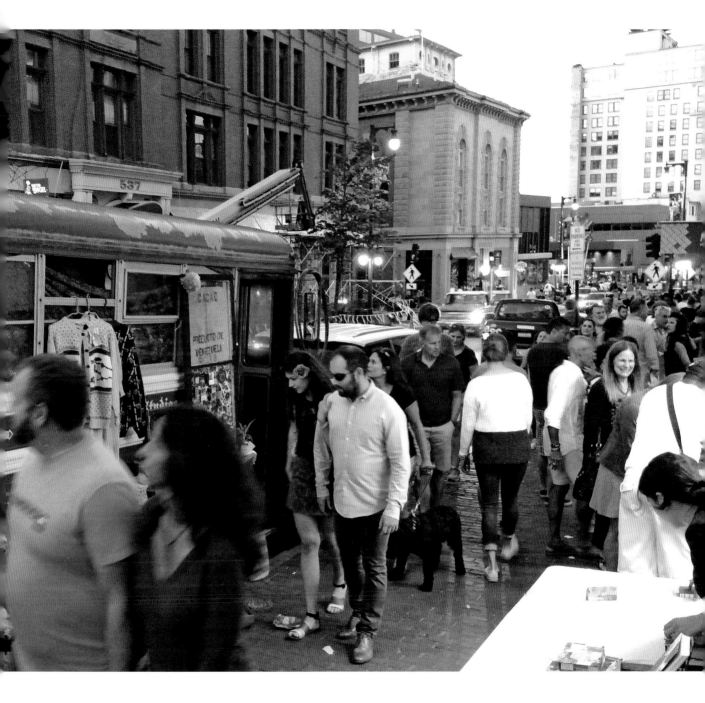

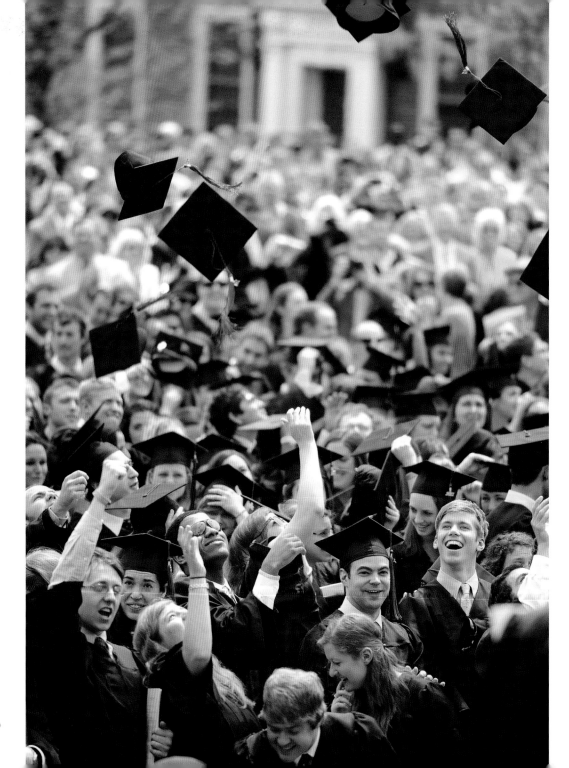

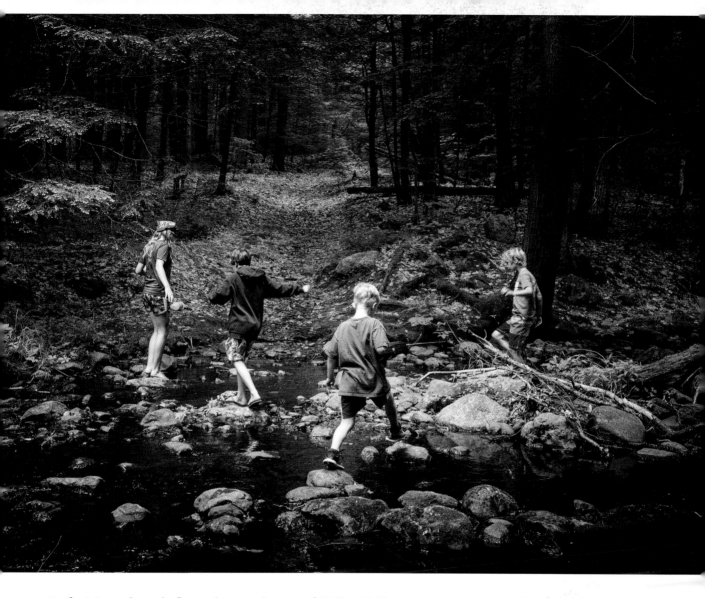

Left: Mortarboards fly at the conclusion of Colby College commencement. *(Fred Field)*

Right: The woods are dark and deep, but not so scary to Maine kids with a sense of adventure. *(Heather Perry)*

PHOTOGRAPHERS

KELIY ANDERSON-STALEY was raised off the grid in central Maine and currently lives in Texas. She was a New York Foundation for the Arts Fellow and has received fellowships from the Brown Foundation and Puffin Foundation. (p. 95)

DOUG BRUNS has traveled extensively with his camera, including projects and adventures in Tibet, Nepal, Bhutan, Patagonia, and Europe. His photography has been published and exhibited widely. Most recently he completed a year-long project, The Maine Literary Portrait Project, portraying fifty of Maine's best-known literary artists. (pp. 20, 21)

YOON S. BYUN is an award-winning photographer who has dedicated his career to telling the stories of people from all walks of life. He was part of *The Boston Globe* team awarded the 2014 Pulitzer Prize in breaking news for coverage of the Boston Marathon bombings. He lives in Portland with his family. (p. 110)

PAUL CYR is a professional photographer from Presque Isle, specializing in wildlife imagery. His work has been published in several books and magazines. (pp. 5, 23, 25, 30, 56, 57, 59, 66, 69, 70, 71, 76, 77, 79)

JIM DUGAN came to Maine in 1989 to study at the Maine Photographic Workshops. He stuck around, and now works as a professional photographer, teacher, and web designer. He lives and works in Rockland. (pp. 44, 45, 62, 88, 89, 100)

FRED FIELD is an award-winning photographer based in Cumberland. He worked at three newspapers, including two stints as photo editor, before going freelance. With more than fifteen thousand assignments under his belt, his work has been widely published in magazines, newspapers, books, and online. (pp. 9, 14, 15, 16, 17, 33, 64, 65, 83, 84, 85, 90, 103, 106)

BENJAMIN MAGRO has worked for many clients and publications and maintains a studio in Belfast. His photographs have appeared in such publications as *The Chicago Tribune, The Christian Science Monitor, The New York Times Sunday Supplement, Horticulture, Yankee, National Geographic Traveler,* and *Down East.* (19, 32, 46)

KERRY MICHAELS is a photographer and writer based in Freeport. Her photographs have been featured in many magazines and books, including *A Gateless Garden: Quotes by Maine Women Writers*. Kerry also co-produced and directed the award-winning documentary, *River of Steel*. (p. 39)

MALORRIE NADEAU is a professional photographer based in Brunswick, where she specializes in family and marriage photography. (p. 35)

JOHNNY PATIENCE is based in midcoast Maine. Born and raised in Europe, the foundation of his work is a unique combination of fine art, travel, and street photography. He shoots only film and has a minimalist approach to gear: one camera, one lens, and natural light. (pp. 55, 87)

HEATHER PERRY lives in Bath, where she has an ongoing series documenting the day-to-day lives of the kids in her neighborhood. Her work has been published in *National Geographic, Smithsonian, The Boston Globe, The New York Times, The Wall Street Journal*, and many others. (pp. 8, 26, 42, 107)

JAN PIETER VAN VOORST VAN BEEST is a fine arts photographer based in Pownal. His work has been published in a variety of magazines, such as *Black & White Magazine*, the *Photo Review, Dance Teacher Magazine, Cadence Magazine, Portland Magazine, Words & Images*, and others. (p. 49)

BRIAN THRELKELD is an adventurer and photographer based in Portland. When he's not wandering in the mountains, he can be most often found riding his cargo bike through town, working at a waterfront restaurant or enjoying time with his girlfriend and her son. (p. 52, 53)

DAN TOBYNE has been involved in photography for more than forty years. His work is on display in public and private collections throughout New England and is featured in several books. He lives with his family in South Hamilton, Massachusetts. (pp. 68, 74, 80, 81, 92, 93, 96, 97, 98, 99, 104, 115)

NANCE TRUEWORTHY has worked as a photojournalist for 46 years, specializing in assignment, stock, and location photography. Her work has taken her from her home in Portland to locations in the Caribbean, Europe, and all over the United States. (pp. 6, 10, 24, 28, 29, 36, 37, 38, 54, 60, 61)

BENJAMIN WILLIAMSON is an award-winning photographer based in Brunswick. He is director of photography for *Down East* magazine and also teaches photography through guided trips and one-on-one workshops. (p. 4, 12, 40, 50, 72, 73)

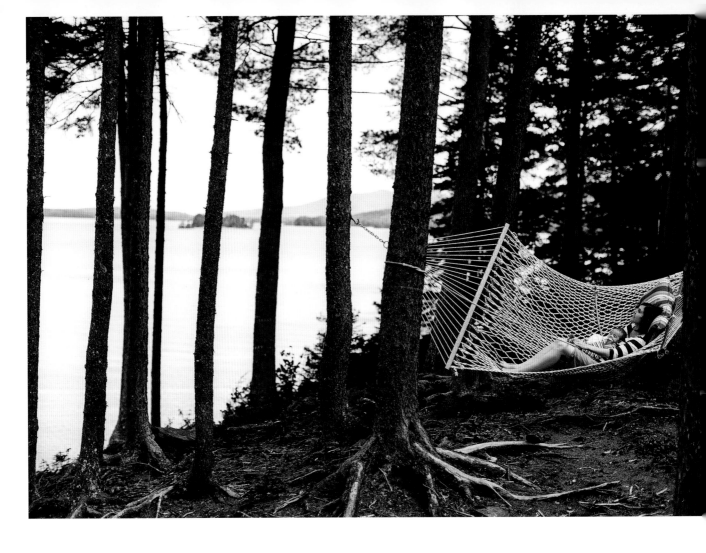

The way life should be.*(Yoon S. Byun)*